Bards Against Hunger

5 Year Anniversary Anthology

Bards Initiative

Bards Against Hunger

Copyright © 2017 by Bards Initiative

www.bardsagainsthunger.com

Published by Local Gems Press

www.localgemspoetrypress.com

Edited by James P. Wagner (Ishwa)

This book is dedicated to those who went to sleep with empty bellies, and to the many people who do their best to feed them...

Foreword

I have been going to poetry events since high school. Back in 2010 I started a publishing company which became pretty popular and successful in a relatively short time here in my poetry-rich home of Long Island, NY. Because of this, I got into the habit of organizing and hosting numerous poetry events and formed and became president of a poetry group called the Bards Initiative with several friends.

5 Years ago, not too long before Thanksgiving time, I was talking with several other poets on our board about events, and we had the idea to put together an event and a chapbook to raise money for a local Long Island food shelter. The event we threw together was pretty packed out and we managed to gather several hundred pounds of food to be donated.

Everyone who participated felt proud of what we did, especially considering with the emphasis on a local shelter which distributed food to the local pantries, we could see the effect of our efforts. So we decided to make it an annual event.

Three years ago, another chapter of the Bards Initiative formed in Northern Virginia (NoVA Bards) and they decided to adopt the tradition of Bards Against Hunger as well, with the food going to a shelter also in their area. This got us all thinking that other poetry groups might be interested in doing something similar, especially since, heck, we were all having poetry readings anyway!

The following year saw 6 events happen, in NY, VA, CT, WI, IN and FL. That was last year. This year for the 5th anniversary we decided to put together a book again, and sign on as many events as we could. The first Bards Against Hunger chapbook 5 years ago had 20 poets in it. This book you hold in your hands has over 120. By the time you get your hands on this book, several Bards Against Hunger events will have already happened, with several more planned, and several more for next year--over a dozen on the roster with more being added all the time. The states as you will notice are not listed alphabetically, but rather in the order in which they entered the Bards Against Hunger project.

I have to admit, when first starting this, I never expected this project would grow as far as it did, but at this point I only see it getting bigger. This book has poetic representation from over 20 states in the US as well as several other countries. Queries keep coming in from all over about the project, and even Universities and Libraries are trying to see how they can get involved.

I personally think this is good for poetry in general--not only has this project formed an inter-connected network of groups in many different areas, but the general public is starting to see how organized poets can become and the good we can do when we work together in such a way. I have no doubt that thousands and thousands of pounds of food will be given to hungry people this year thanks to our project. Thank you all for being a part of it, and I look forward to walking with you all farther down this path.

~ James P. Wagner (Ishwa)
Bards Against Hunger Founder

Table of Contents

NEW YORK

Donald Allen

Fourth Down and Two

A child looks into a camera lens,
so sadly with his big brown eyes.
Eyes that are filled with tears,
and devoid of hope.

I see him for only a few moments,
and then he is gone.
In the warmth and comfort of my home,
the football game returns to the TV screen.
It's fourth down and 2. Will he make it?

I can remember the 800 number, how strange, how haunting.
It only flashed on the screen for a few seconds.
under the picture of the boy with the big brown eyes.

Out of body I see a hungry man walk past the telephone
to his refrigerator. Turkey, roast beef, salami, or bologna;
his choices are too many, what will he choose?

Turkey and American on Rye with mayo.
His plate full, he turns and sees the telephone again.
He pauses and remembers. The phone call…

The game is now over, we won, they lost.

I look at the remaining pieces of my sandwich on the plate,
once again my eyes were bigger than my appetite.
I walk to the trash, open the lid … and stop.
Will he make it?

I put down the plate, and pick up the phone.
Life changes for a boy with big brown eyes.
My life changes for the better as well.
He will make it after all.

Donald E. Allen is a member of the the Bard's Initiative, and The Academy of American Poets. Samples of Don's writing can be found on DonaldEAllen.blogspot.com

Sharon Anderson

Spare

Night was falling, the room was in shadow,
but Mom wouldn't light the lamps
until it was absolutely necessary,
and we could still see well enough to eat.

Supper was a feast that evening.
Tom had caught a rabbit,
so the "stew" that night
actually contained meat.

We held hands around the table,
bowed our heads, said grace.
I added my own silent prayer
that there might be eggs for breakfast.

We had never been rich,
but this year was particularly bad.
A drought claimed most of our crops,
and Dad was laid off from the mill.

Yes, we survived, and things got better.
Dad found a job, the drought ended.
Mom turned the lamps on at dusk,
and always served meat for supper.

But I never forgot that bleak, spare year,
and the fear I felt in my heart.
Never forgot those times when
my evening prayer included a plea for eggs.

Sharon Anderson has been published in many international and local anthologies and received a 2014 Pushcart nomination. She is the author of *Sonnets Songs and Serenades*, and *Puff Flummery,* and *Chutes and Ladders.* She is an advisory board member for NCPLS and the Bards Initiative and a PPA co-host at Oceanside Library.

Mark Blickley

Screaming Mime

I should speak out when they abuse
This pasty-faced artist who decided to choose
Being trapped in silence with make up queer
I may not speak, but I can hear.

The taunts, the insults, and the hate
Towards street performers who refuse the bait
Of ridiculed anger through vulgar gestures
Believing performance is a continuing semester

Of learning to grow within painted smile
Ignore the assholes, concentrate on the child.
Who laughs with joy or open-mouthed wonder
Yet tosses no coins as my stomach thunders

Breaking the silence, begging for bread
My intestinal rumblings plead to be fed
A steady diet of human compassion
Through the clinking of coins in an appreciative reaction

To my ancient art and enduring hunger
Selling myself like a common whoremonger
Hoping to satisfy an insatiable crowd
In tight fitting Spandex, a seductive shroud

Ignoring lewd sneers at my exposed anatomy
That I've twisted and stretched in hopes it would flatter me
As my muscles contort and my body sings
A silent song that once entertained kings

Mark Blickley is the author of the story collection *Sacred Misfits* (Red Hen Press) and recently published a resistance text based art book in collaboration with fine arts photographer Amy Bassin, *Weathered Reports: Trump Surrogate Quotes From the Underground* (Moira Books, Chicago) which the publisher sent to the White House. He is a proud member of the Dramatists Guild and PEN American Center.

Alice Byrne

Dancer

Like the dancer she once was,she bent into a deep plié
The homeless vagabond was shuffling along and dropped to
sit on the ground,perhaps collapsed.
Scruffy beard ,dirty clothes,hungry despair.
She reached out an arm in his direction,first a sandwich,
Then,then a treasure,clean socks.

Along the yellow brick road,the homeless drop to the ground weeping
as the blinded play video games on iPads and phones.
Janice Joplin sings of Freedom,nothing left to lose.

Drop the phone,feed the masses.Dancers Drop into pliés

Alice Byrne is a mother, grandmother, psychotherapist who has been
writing poetry and singing for this lifetime.

Paula Camacho

Backyard Visitor

Surrounded by snow
it pecks at the ground,
laboring for breakfast
on a speck of brown earth.

I watch from my window
on this cold December morning,
witness to the struggles
of a wintering bird

and think about the millions of people
who do not have enough food,
Asia, Sub-Saharan Africa.
In America forty-eight million
go to bed hungry each night
among amber waves of grain.

I toss some bread outside
empty my pantry
walk the cold December morning
to the nearest shelter.
Back home I say a small prayer
over my next meal.

Paula Camacho moderates the Farmingdale Poetry Group. She is President of the Nassau County Poet Laureate Society. She has published three books, *Hidden Between Branches, Choice, More Than Clouds* and four chapbooks, *The Short Lives of Giants, November's Diary, In Short,* and *Letters.*

Lorraine Conlin

Bargain Days

Dad shopped weekly at the A&P
from lists made by Mom
Alberta free-stone peaches
a box of loose tea, on-sale-meats
produce and weekly specials

Aside from the list, a *Box of Bargains* –
dented, misshapen often label-less cans
the store manager sold for a fair price –
were stored in our basement pantry
saved for pot-luck-dinners
when money got tight

Mom threw out the sometimes surprise contents
saying old sprouted peas displeased her
She'd juxtapose unidentifiable cans
with clearly marked ones,
in size order, hoping for a possible match

Pork and beans, with or without labels,
Dad's "Musical fruit, the more you toot" line,
on the shelf with his "Pull my finger" routine
never seemed to run out like we did
when he'd *cut the cheese*, then

blame the dog, sent Peppy into the yard
when Mom gave Dad her look

Yet the poor dog sat by Dad's side
waiting for bargain treats
nibbled on scraps tossed his way
loyal, ready to take the rap when
a hint of flatulence sent him
cowering to the back door

Lorraine Conlin Nassau County Poet Laureate (2015-2017), and Vice-President of the NCPLS. She is on the Board of the Bards, Events Coordinator for Performance Poets Association and hosts *Tuesdays with Poetry* and other local venues. Writing is her 'Prozac." Lorraine is a breast cancer survivor and "a student of life." www.lorrainelofreseconlin.com

Linda Trott Dickman

Plated

flour – 3 measures
water – 1/3 measure
leaven – breath of I AM

kneaded
pounded
scored

sent to the oven
baked
risen
cooled

broken
plated

You.

Peter V. Dugan

Outside the Garden

The homeless and anonymous
push shopping carts
packed with their collection
of bottles and cans
 or
carry large plastic bags
filled with their sole possessions,
their treasures of life.

We try to ignore them
and view them as nuisances
 or
pests we encounter
on the street.

They nap on park benches
 or
over heating vents,
panhandle on street corners
and subway platforms.

They feed at dumpsters
and seek refuge in basements

of burnt-out tenements
 or
use makeshift shelters,
of card board huts,
 or
sometimes spend a night
in abandoned vehicles,
the stripped shells,
carcasses of Lincolns
and Caddies that seat six
and sleep three.
 But
from the penthouses
 between
Park and Columbus
we all look like
a
 n
 t
 s.

Peter V. Dugan is the Nassau County Poet Laureate (2017-19).
He has authored five collections of poetry and hosts a reading series
at the Oceanside Library on Long Island.

Viviana Duncan

Take Back The Power

I would consider a Zen world,
 let other people's pain roll off my back...
accept a pre-determined order.
Maybe I am just an imbecilic bug in this world of
Wall Street attunement,
 but
Johnny is learning his lessons sitting on the lunchroom floor-
all rooms are filled-
my taxes going to guns not school seats-
his teacher using books
not explaining it was wrong for Jefferson to have slaves
while he declared equality for all,
wrong that he should rise from sleep in a soft bed draped in embroi-
dered lace covers
while his brethren of dark flesh sleep on mats made of hay
eating porridge with horses while our founding father cuts his meat on
china dishes and drinks from crystal goblets-
oh Sally, my Sally!! Sleep with me and be my darling slave!!
I can't Zen..
I can't bend and dive in cocoons
blinded by pretty his(tory) while her(story) is unwritten
where color of flesh determines freedom-
where loving the same sex or not determines acceptance-
where Johnny plays with blades

and little Jane puts rollers on a clitless Barbie.
I can't Zen
while Ken is missing his penis,
while a Constitution is considered legal without a womyn's signature.

I can't Zen,
like a cross legged Buddah
while I don't have a say where my money goes-
just come home from the slavery of work
knowing without a paycheck there is no roof .
Am I dead or aloof? What is ahead for me
as I see each month turn into another
will I ever be a mother?
Fill my bed with a lover who will
carry the torch with me..?
Proud that his woman has the urge to rant!!
 the means to encourage screams!!
To inspire the tired
lower the higher
heighten the lower
and teach those who cower
to raise their voices and take back the power!!

Sophia Emma

Billy Joel

His baby's all grown up
doesn't need her daddy anymore
now he walks with less purpose in each step
he moves slow, unsure.
He's immortalized in song, performed a thousand shows
sold out arenas, but now it's just darks bars
with a stranger that he vaguely knows
by now he blends right in,
He's done it all, hit his prime,
lived the life of rock and roll

His house is much too big, a castle of red brick
and he, the lonely king, sits at his baby grand
the only thing filling the room, the curtains tightly shut,
he's had so many queens, he thinks of them and sings
between his sips of Jack
a full bottle always on deck
it dulls the pain a bit,
memories of a stronger man

One more glass will make me happy
he lies and pours one more
he's quickly losing faith
in Jack Daniels and King James

his friends in earnest pray
and beg him to seek help
they try to lift him from his rut
but his feet are firmly planted
he has no energy to move

He's too old now
it would be a waste
to even lift a foot
he shuffles to the black and white keys
pajamas inked with stains
so different from his glory days
he reminiscences, sits down and plays
his fingers move like clockwork
automatic from the start
with eyes welling up, he sings Downtown Alexa,
the bottle nearly gone.

Sophia Schiralli works in Education and loves exposing her students
to great literature, especially the classics and poetry. She was former-
ly a linguist in the Army and is a Michigan Wolverine. She loves to
travel, learn languages, read, and write.

Kate Fox

Sunday Morning

Lying in bed
My mind as rumpled
As the blanket
I'm wrapped in
I listen to the sound
Of you in the kitchen
And I will myself
Awake
Padding down the
Stairs and into
Your space
I reach for the coffee
As you mix
Whatever it is
You've decided to make
I'm as comfortable as
I imagine your
Plaid pajama bottoms are

Long Island poet, **Kate Fox**, is a mother, breast cancer survivor, and award winning author of the collections **My Pink Ribbons, Hope** and **Liars, Mistruths and Perception**. Her fourth collection, **Angels and Saints,** will be released in mid 2018. www.katespityparty.com

Maria Iliou

Observing Water's

Observing water's
Within nature
Tranquility
Hidden subject
Of interest
Emerging upon
Platform

Amazing moments
Within journey
Absorbing my
Intuitive wisdom

Focusing on
Visual sign
Eye capture words
Forgotten tools

Only memories
Remains…restoring
Photo's images on
Computer file in
Corner of
My mind

Tony Iovino

Progress

Arms aching, back groaning,
With the case of Poland Spring
I struggle.

From shelf to cart,
From cart to car,
From car to house.

Wouldn't it be grand
If someone could invent
A system to bring water
directly to our homes?

Perhaps we could use pumps,
And pipes.
Maybe some sort of spigot device
could be fashioned to turn the water
On and off at will?

Oh, how far we've come!
Our poor ancestors had to haul water
from river and spring,
In buckets and pails.

Not us. All we have to do
Is drive, and carry

From shelf to cart,
From cart to car,
From car to house.

Tony Iovino is the founder and host of the acclaimed Summer Gazebo Reading series in Oceanside, NY, now in its 11th season. He is the author of the novel "Notary Public Enemy" (Diversion Press, 2011) and numerous published poems and essays.

Ryan Jones

Arboreal Shroud

Once there was a shared system of beliefs
Folk of all nations were but supplicants
They proffered their offerings to the earth
Incantations were lifted to the skies
They implored their gods to secure their needs
Not despite nature, but as part of it

All adherents knew they were owed nothing
They worked the land without expectations
Survival was sought from what nature provided
Mercy of the gods, and ancestral will
Through their labors and memories, all knew
Nature requires respect, not replacement

Yet time ground them down and war broke their ways
The years, the decades, the generations
The centuries and the millennia
The warlords, the entitled, the greedy
The persecutors, the scornful, the fire
Nature itself gasps for its last few breaths

The ways of old have fallen to ruin
Destroyed by sword, flame, lust, and privilege
Urged by the jealously spewed words of hate

Those who toil and strive were brought to an end
Over the precipice they were driven
Their utter extinction replaced with "rights"

Lost as nature's bastions are thought to be
The last standing trees have yet to be felled
Yet there are plains with soil still unbroken
Still there are mountains unworked and uncarved
There remains hills yet unexcavated
The final island has not been assailed

In a forest, dense to date with tall trees
As wide and virgin as these times allow
The modernity of three thousand years
Has failed to take hold, and the primal thrives
As nature has intended all along
But it is not without humanity

Therein sits a circle of cloaked figures
Twelve is their number, one in the center
He stands as they sit, focusing on him
The woodland creatures dare not come near them
They are fully robed and hooded in green
More recognized by voice than by eyesight

They meet as the sun is at its zenith
Though unseen, a few light shafts reach the ground
Painting the forest floor with sunlight
The gathering meets at this time daily
At this location, so sacred to them

They are grateful for yet another day

The central figure raises a hand up high
He chants, "Today we count twelve once again
By the gods we have gathered and eaten
By the gods we have breathed and we have bred
By the gods we have shirked off diseases
By the gods we remain undetected"

The circle loudly exalts these words
Declaring their truth and their thankfulness
Each holds forth a few strands of human hair
None sharing in length or hue of color
Each is collected by the man standing
Once more he takes his central position

He continues, "Our ancestors are here
We offer their essence to you today
That they may assist us, and assist you
Care for them, as we sustain you, our gods
Thus we give thanks for our longevity"
To the canopy the tosses up the hairs

To the circle he shouts rhythmically
"By our hands we planted the grain and reaped
By our hands we captured the beasts and ate
By our hands we gathered wares and built
By our hands we have woven our garments
By our hands we keep our ancestors' creed"

Now the circle takes up the chant with him
"Still we accept life from the midday sun
Still we pursue our ancestors' wisdom
Still we take and return only our needs
Still we rely on what nature provides
Still we defy those who wish us to cease"

The circle rises and each holds an item
Some grasp a nutshell, a root, or feather
Others a bone or animal organ
As tokens of nature's bounty, unused
These their gods and ancestors will consume
Sustained by what mortals have no use for

The circle casts these things into the woods
And by so doing, tend their forest home
Together they hum, "Our oath still remains
Let those who bring harm come at their own risk
For as we live we will resist, unseen
In and beneath our arboreal shroud"

Ryan Jones began writing at an early age. Ryan's topics of interest include nature, human and natural history, mythology, and personal and collective experience. Ryan holds a Bachelor's in English with a Master's in childhood education, and works with children by profession.

Mindy Kronenberg

Baby Bottle

As I remember it,
the TV commercial for
a special bottle
with a collapsible liner
and rubber-soft nipple
played soft music
while the camera cuddled
Madonna and child,
both pale and silent,
pantomimed parenthood,
Mater well-coiffed and imperially
slim, child plump and
rosy skinned.
When was the world truly a place
swollen with milk
and sweet dreams, a soft voice
singing like a breeze through
lace curtains, a music box
of privileged anthems
and the cream-colored, gold-gilt
pages of soft-spoken fables?
What small mouths still quiver
for a breast run dry
in the desert, a poisoned river

or a jungle hacked bare
of trees, cradles crashing down
without a trace of lullaby.

Mindy Kronenberg is an award-winning poet and writer published widely in the U.S. and abroad. She teaches writing, literature, and arts courses at SUNY Empire State College, for Poet & Writers, BOCES, and across Long Island libraries and arts councils. Ms. Kronenberg edits *Book/Mark Quarterly Review*, and is the editor of *Oberon* poetry magazine.

Ellen Lawrence

evolution

as grass evolves from winter brown
to a shade of emerald green
pale rays of sunshine filter down
 a springlike golden sheen
on daffodils whose yellow hues
announce, spring is on its way
winter frost but a memory
as April wends toward May

robins return from southern skies
trilling a renascent tune
fragrant lilacs burst into bloom
as May approaches June
summer lags not far behind
warmth hanging heavy in the air
daisies nod as roses climb
towards heavens blue and fair

autumn in umber and ochre tones
as seasons change once more
leading to another

Ellen Lawrence is a retired business owner, and a great-grandmother who has been writing poetry since she was ten years old. She has written poetry columns for Tobay Hadassah Newsletter and JJC Bulletin. A member of Taproot Workshop and LIWG she was born in Switzerland at the start of WWII. She is currently writing memoirs of life during, and after, the war. Her poetry can be seen in many anthologies, including Bards Annual, PPA

Patricia Leonard

Loose change

Sometimes I wish I could get the words out fast enough.
I want to convey my deepest thoughts to you,
The power of saying no.
The authority it bestows.
I need some boundaries.
I drew with them the invisible markers you got me
That one year:

Abused.	Mentally. Emotionally.	Abused.
Abused.	Taken advantage of.	Abused.
Abused.	Inhuman you beckon.	Abused.
Abused.	Tattered. Discouraged.	Abused.

Away you go.

I see little clouds of dust come up around your feet,
Hug your ankles with anger
Clinging to the dearest part of your hatred for me.

This is why you'll never love me the way I deserve.
But who am I to judge what I deserve?

I've been walked on and over,
Like countless amounts of pennies
Scattered across every block on the city
Old, dirty, really not worth anything.

Your worth is worthless

Patricia Leonard is a 29 year old writer from New York. She has her BA in English linguistics and creative writing. Her work has been featured in Three Rooms Press' yearly anthology, Maintenant 10 and Maintenant 11. Also featured in The Voices project, Broke Bohemian and upcoming in CultureCult. She is a poetry and creative non fiction writer who always leaves her readers wanting more. Her style is raw and captivating; leaving you with a vivid memory that you'll never forget.

Maria Manobianco

The Need to Let Go

How can I let go of your hold on me
I had planned to be with you forever
Though you had departed, I am not free
Our love, too strong to break or to sever

I walk the hallway of recorded scenes
with each step I relive the joy, the pain
and every portrait lives its perfect dream
while time marches in an endless refrain

In the light of day, I let go of you
distract myself with family and friends
But with the night my resolve is untrue
And I am much too old to play pretend

As long as love lives beyond time and space
we'll be united by God's divine grace

James McMahon

Sad girl

I saw a sad girl on a sad bus in a sad part of town
She threaded a stroller through the door and plopped
Exhausted on the perpendicular seats opposite me
Struggling with her cart, two big bags and a big sad eyed baby
Her beautiful young face encrusted deep watery sad eyes and mouth
no signs of anger, just resigned
a spirit beaten down by life,
solitary
she looks longingly and lovingly at her child
wants to talk to him, comfort him, but can't summon it
a sad loving pool of longing and helplessness
a relentless grief entombs them both
no way out
no way out of the prison of the centuries
will this baby be shot one day, this boy?
Will this lady die sad one day, this girl?

James McMahon is a retired psychologist and psychoanalyst who has been writing poems and lyric essays all his life. His poem, 'Free to twinkle gloriously' was read on the radio recently in UK as part of their poetry day celebration.

Gene McParland

The Pavement is Hard and Cold

The pavement is hard and cold,
even with these cardboard boxes
stretched out beneath me.
No grating or outside heat pipe
to help against the cold tonight.
I got to protect my shopping cart;
my life is stored within those plastic bags.
I got my deposit bottles
and some stale bagels, too!
Also my wine bottle!

People walk by
trying not to see me, but
they often take a peek anyway.
Screw them! Who cares!

Hey, I ain't bitching about anything.
I like the street life;
I can relate to it.
Me and the other lost souls
drifting and sailing along
on the fringes of society.
These streets are our ocean of sorts.

Hungry, sick, broken, but not dead!
To me these people in suits and designer clothes
are the ones living unreal lives.

The only thing I sometime wish
is that I had lost my life in the jungles of Vietnam
instead of just my mind.
Semper fi!

Gene McParland (North Babylon, NY) is a graduate from Queens College, and possesses graduate degrees from other institutions. His works have appeared in numerous poetry publications. He is the author of **Baby Boomer Ramblings**, a collection of inspiring and positive-life living essays and poetry. His new collection of poetry, entitled **Adult Without, Child Within** is now available on Amazon and from various outlets. Gene loves poetry and the messages it can convey. Gen also acts in theater and film.

Terrance O'Dwyer

The Irish Famine: One Woman's Thoughts

The world knows so little of what we thought,
Of daily stresses as food did rot
Of screaming babies in agony unfed
Of silent children, once laughing, now dead.

Of caring for infants in incessant cold
Of aching joints for quick they grew old.
Of long wet days and gruesome nights
Chronic weakness meant no fight nor flight

Of anger seeing good food go away
Knowing Whitehall wanted our deaths this day.
The world does not care about my thoughts
My suffering and despair, it matters naught.

In time we could not pay the rent
In March then came the sheriff sent
The owner of my once sovereign plot
Sent to the road; us, left there to rot.

And there I saw my son did die
Long gone the days when he made me smile.
Long gone the days when I felt so free

Instead I'm alive in this agony.

O Lord what did we do to deserve this fate?
This thing called love seems more like hate.
Seems the worms have the better life;
My dying family filled with strife.

One million starved; did Whitehall care?
Indifferent they; they would not share
The meats and grain sent England's way.
Great joy they had our dismay.

I'm very weak; little time have I
And now I must, must say goodbye
To he who always tried to care for me
Someday soon united we'll be.

I am dying now, my final task
A bitter question that I must ask:
If in your likeness that we are made
Why can Whitehall such image degrade?

Mr. O'Dwyer is a retired bond analyst who is developing his sense of meter and metaphor to explore history. Topics of interest include the erroneously called Irish Famine—how could over 1 million people have perished of starvation while Ireland exported record amounts of grains and meats—and current political scene.

Marlene Patti

I am steel

Don't you know?
I am steel
feelings, easily formed
yet I melt them
they flow
slowly they fade.
Never existed.

I am steel
I loved once,
and never again
I harbor no attachment
your presence doesn't
make me, break me.
Never reliant.

I am steel
I welcome change,
transformation.
I expect nothing
I am content knowing
you will let me down.
Never defeated.

Cold, heartless, strong,
common. I am steel.

Marlene Patti is a native of Chile. She resides in Selden with her husband, two sons and cat Penelope. She is a disability rights advocate and active as Chair of Town Of Brookhaven Disability Task Force. She is eager to encourage people of all abilities to reach their fullest potential.

Alphonse Ripandelli

Mom's List

Cigarettes.
Breakfast bowls,
I need those.
Frozen dinners.
Oh, paper towels
toilet paper.
Cigarettes.
Water, the good kind.
Butter
Milk
Eggs
and
cigarettes.
Did I say cigarettes?

Rita B. Rose

Seasons of Daydreams and Want

Apple and Pear branches dancing in the hearth
Sweet tastes of summer fun—
Autumn Higan blossoms sugary as cherry pie
And Hickory timbers pungent and nutty
Delicious to the throat—

Chestnuts roasting on a barbeque grate,
Plentiful are the Lemon cookies as they sour
Christmas palettes—
In a pot belly stove a cord of Maple wood crackles,
The aroma is evocative; Mama is cooking Buttermilk pancakes
On an Easter Sunday morn—

Does your mouth slaver thinking back on better times,
Can dreams fill empty tummies with seasonal delights?
Can yester visions offer sustenance
To the many homeless who are famished?
Are they mighty enough to dampen the hungry growl—?

Rita B. Rose is a multimedia artist who has always had a special love for the Literary Arts. She has gained recognition amongst poetry groups in New York and abroad. She has performed her works for colleges, organizations and social programs. She is a published author and poet and is presently compiling her current poetry into a collection for publication - 2018

Robert Savino

Short Reach of Outstretched Hands

History has established tradition for this season
of fallen leaves, unraked, in a stir of acorn shells
with stories of spirits passing through ceilings
of years, to reap soil and scatter seeds.

I remember our home filled with family,
mouths filled with food,
praise and thanks filled the air
with each sip of cider or homemade wine.

From our window I could see young Douglas,
next door, peeking through the blinds,
tears in his eyes,
not to have a seat at our table.

I break away from the festivities
and pack two drumsticks for Friday.
And, at our Sunday banquet,
between Wonder Bread bookends,

I fill a Monday morning school boy's lunchbox.

Robert Savino, Suffolk County Poet Laureate 2015-2017, is a native Long Island poet, born on Whitman's Paumanok and a Board Member at the Walt Whitman Birthplace. Robert is the winner of the 2008 Oberon Poetry Prize. His books include *fireballs of an illuminated scarecrow,* his first collection *Inside a Turtle Shell* and recently published *No Distance Between Us,* a bilingual collection of Italian American Poets of Long Island.

Andrea Schiralli

Missing You

Daydreams fill my solitude
Tasting of your memory
Phantom arms
Tuck me in each night
While invisible lips kiss me to sleep
The last thing I hear is still "Sweet dreams, angel"
I'm haunted by gossamer thoughts
Disintegrating as soon as they become too real

My soul, it reflects your image
Back to my rose-colored lenses
Implanted over my field of vision
Since that fateful February day

Confusing, intoxicating, delighting
I submerged into you
And your world
Bewitched by it all: your Beauty, Body, and Mind

The way you make my imagination run wild
They way you push a piece of hair out of my face
The way you move your calloused thumb across my body
Reminding me, *here I am*

Offhandedly obliterating any defense I haven't yet invented
I lose my senses, dazzled
By You, with your idealized halo

Andrea helps students with their college application essays; giving them makeovers provides her with "a sense of control in a world full of chaos." Her favorite writers are Fitzgerald and Maugham. She is addicted to Hello Kitty, the color pink, and anything that sparkles.

Gayl Teller

Guilt

I'd like to stay outside awhile and just
watch the petunias plunging in peace…
I ask myself, Is that all right?
Can I just let the red dazzling dahlias'
giant heads overwhelm my thoughts?
I love the feel of these last azaleas
filling me into their fuchsia felicities…
So why isn't my empathy enough?
While colleagues gather at Lincoln Center
to march for faithful charge of this earth,
while women rally to maintain their domain
over their own eminent wombs,
I'd like to stay outside awhile and be
beyond the claspers, harassers, safe at home.

Gayl Teller, Nassau County Poet Laureate for 2009-11 and the 2016 Walt Whitman Birthplace Poet of the Year, is the author of 6 poetry collections, most recently, *Hidden in Plainview* (Cherry Grove, 2015), and the editor of the poetry anthology *Toward Forgiveness* (Writer's Ink, 2011--NY Arts Grant Winner). Winner of many poetry awards (Westmoreland Arts & Heritage, Edgar Allen Poe, Amer. PEN Women), she teaches at Hofstra U and directs the Poetry Series of the Mid-Island Y, in Plainview, NY. See www.gaylteller.com.

Marc Torres

Summers in the Bronx

Are constant heat waves,
That linger through the winter.

The blocks are chalked with happy faces,
Blood, sweat, vomit,
Dog shit, old gum, and
Newspaper pages that've been read and empty bottles of Puerto Rican
Rum.

The parks are filled after dark,
With laughter, Pit Bull barks,
And sounds of children playing hide and seek echo,
Inside apartment building windows.

The clanking of the old radiator on the wall,
Wakes me up, makes me sweat
And forces me outside to find a cool breeze that stays lost,
Because there are no summer winds in this part of the city.

So, I head to the Bodega, for a sandwich, coconut water,
And A/C blasts that cool my heated Caramel skin.

I wait, wait, wait, for my food and watch the hoodlums outside,
As they rob two kids each for fifty cents that only make,

One measly dollar.
A dollar that rings when dropped on the counter for some loose cigarettes.

I grab my black plastic bag,
And get out of there as fast as the squad cars drive by,
As fast as me trying to win a 500-yard dash.

Marc Torres was born and raised in the Bronx in New York City. Marc focuses on Poetry and Playwriting. He is currently a student at York College in Jamaica Queens, studying Creative Writing and Journalism.

J R Turek

Famine

I am ravenous for world peace
craving a slice of joy with a side of smiles
on the menu for every Monday morning

I am famished for genuine friendship
the real kind that doesn't stop to look
at clocks when an ear and a heart are needed

I am craving a community where everyone
is equal in all eyes and all ways, where no one
stands on a self-made soapbox at others' expense

I am greedy for an end to struggle
more programs for more assistance for needy people
less politics for more pro-bono proactive agencies.

I am starving for an end to hunger
food banks with full pantries for families
who can't make ends meet can meet an end to hunger.

I am consumed by an appetite to help
to push a cart of groceries through the door of hunger
to cease malnutrition, to write a recipe of change –

I am hungry to be a voice to end hunger.
Forever.

J R Turek, Bards Laureate 2013-2015, Bards Associate Editor, is 20 years as Moderator of the Farmingdale Creative Writing Group, twice Pushcart nominee, author of *A is for Almost Anything* (2016), *Imagistics* (2015), and *They Come And They Go* (2005). Poet, editor, workshop leader, PPA host, and poem-a-dayer for over 13 years, the Purple Poet collects dogs, shoes, and poems. msjevus@optonline.net

James P. Wagner (Ishwa)

As The Crow Flies

Which way is main street?
2 Miles that way as the crow flies...
As the crow flies...
Yes, crows can fly and we cannot
but is it possible that the meaning
of this saying is brushed under the rug
overlooked, shrugged aside
so often.
flying would admittedly be easier
than walking, running
or driving,
but maybe it's not the flying
that's so admirable
maybe it's the fact
that a crow flies straight
that makes their destination simple
no grids or crooked pathways
winding roads or signs
calculating GPS's to throw them off point
they stay true
focused
a goal in mind
and the patterns of the weather
being the only major cause
for concern.

James P. Wagner (Ishwa) is an editor, publisher, award-winning fiction writer, essayist, performance poet, and alum twice over (BA & MALS) of Dowling College. He is the publisher for Local Gems Poetry Press and the Senior Founder and President of the Bards Initiative, a Long Island based non-profit dedicated to using poetry for social improvement. He was named National Beat Poet Laureate of Long Island, NY for 2017-2019. He has been on the advisory boards for the Nassau County Poet Laureate Society and the Walt Whitman Birthplace Association. James also helped with the Dowling College Writing Conference. His poetry is also used to autism advocacy, having appeared at the Naturally Autistic Conference in Vancouver and in Naturally Autistic Magazine, as well as his essays. James believes poetry is alive and well and thoroughly enjoys being a part of poetic culture. His most recent collection of poetry is *Ten Year Reunion.*

Margarette Wahl

Carl's Cleanup

They gather outside his house.
Together, wearing work gloves
reindeer antlers, Santa hats,
and goggles they collect leaves
Get Well wishes for their colleague.
A group of Home Depot workers volunteer.

With rakes, shovels, leaf blowers
they fill 60 shiny ebony bags with smiles.

Carl was cleaning out his gutters,
when a neighbor found him on the ground.
He had suffered a heart attack,
but recovered .

On a brisk Autumn day
colleagues open their hearts
and calendars for a man they appreciate
even when he's not in his orange apron.

Margarette Wahl is a native Long Islander. She is on the board for Bards Initiative. She is published in a number of Anthologies and two chapbooks of her own work.

Herb Wahlsteen

Lone Wolf

Pines rumble through this frozen night
like poor ones grumbling from their plight.

The stalking moon kills most the stars.
Earth's ignorant of all her scars.

A very cold wolf prowls for food.
He wants what wisdom works his crude

and natural life. The hare and fowl
are his solutions. Hear him howl?

He's lost – alone. This cold woods leaves
no life and hunger. Hear? He grieves.

He howls his anguish to the moon.
He longs to leave his troubles soon.

Herb Wahlsteen was a finalist in the *Yale Series of Younger Poets* contest, placed 3rd in the *Writer's Digest* 77th Annual Writing Competition: Rhyming Category, and has had poems published in: *Long Island Quarterly,* the *Great South Bay Magazine, The Lyric* magazine, *Paumanok Interwoven, Suffolk County Poetry Review, 2015, 2016, 2017, Bards Annual 2015, 2016, 2017, Form Quarterly, 13 Days of Halloween, 2015 and 2016, String Poet* (2 poems translated from the French, 2 poems translated from the Spanish), and *Measure* magazine.

George Wallace

Night Train Coming

a night train is coming, seagulls are circling the dark skies of your city, there is news from the front and the news isn't good, broke tooth, spear through the chest, smelt iron heated beyond all recognition, i am the melting pot and i bear terrible news, war is every damn where, if you touch me troops will come pouring out, my guts are grief, my legs are a deluge, i am molten lead and i am dangerous, this rag in my hand was a schoolboy once, this broken spine is a book of latin verbs, how can i conjugate this, my teacher is a walking stick and i am a bridge across the monangahela, i come from nowhere and i am going nowhere

once there was a cornfield, once there was fire in my belly, hoof prints and smoke, a saddle for horses, this plug of tobacco was a heart once, these curses a mother's caress, i am no longer one of you people, there is no cover left inside me, i am a dead possum in a riptide, i will cling to any bridgehead, any torn flag or gunnysack, the river that runs dark in me runs dark in you, i'm talking smack and i know it, mudslide, undertow, i have walked right through my boot-straps and now i am here to tell you, gather me up in your arms, your speeches are chocolate chips your proclamations cotton candy, i was minted from your gold but could not stay that way

and your businesses profit from the ruins of my mouth, and i will take

pennycoins from anyone, anyone! your open palms are immaculate
graces, i begrudge you nothing but will take a back seat to no man, i
am a caterpillar in your paradise i will eat your green leaves up, your
skin, your hair, your eyes in mottled sunlight

do you see what you have done to me, these are my words, do you see
what you have done to me, they are your words too

a night train is coming, seagulls are circling the dark skies above your
city.

George Wallace is writer in residence at the Walt Whitman Birth-
place, first poet laureate of Suffolk County, LI NY and author of 31
chapbooks of poetry. He is founding editor of Poetrybay and Long
Island Quarterly, and co-editor of Great Weather for Media.

Donna Zephrine

Food! Finally...

I have not eaten a morsel of food since lunchtime
My husband got home late from work and this is too late to eat dinner
for me
I can't help but to be annoyed at this inconvenience
My stomach is growling
I am worried because I'm beginning to get a headache from the
hunger
One repeating question
"Will it be crowded?"
I am waiting in line
Being so close to the food makes me feel even hungrier
There are so many people here
I hate lines at the buffet
I feel bad for feeling so impatient
Everything looks delicious to me so I put it all on my plate
Food! Finally...
Everything looks delicious, but I sparingly add it to my plate to make
sure there is enough for everyone
I feel bad for all of us
I hate that there are so many people suffering alongside me
There are so many people here, including too thin children
Being so close to the food makes me feel grateful
I am waiting in line
"How long can one live without food?"

One repeating question
I am worried that my body is shutting down
My stomach is not growling any longer
I can't help to think how my life has spiraled downward
My husband got laid off from his job four months ago
I have not eaten a morsel of food in six days

Donna was born in Harlem New York and grew up in Bay Shore, Long island. She went to Brentwood High School and graduated from Columbia University School of Social Work in May 2017. Donna currently works for the New York State Office of Mental Health at Pilgrim Psychiatric Center Outpatient SOCR (State Operated Community Residence. Donna has participated in various writing workshops such as the veterans writing workshop at Fordham Lincoln Center. Currently Donna is studying for the social work licensing exam and works creative writing in her spare time.

VIRGINIA

Steve Konrad

Shroud

Commenced against a tyranny
This country went to war
Aristocrat conspiracy
For slavery evermore

That war ended long ago
Why worship the wrong side
Truth can't be rewritten
With those who've long since died

Those men were never heroes
Treason ran throughout their veins
A horse trodding their property
Them indignant at the reins

You who flap that fetid flag
Are traitors to your race
For we are all but human
That cloth is out of place

Dixie will not rise again
Say goodbye its time to wave
Wrap your body in that banner
Go join her in the grave

Mike Croghan

Disobedience

It was only an hour before the appointed time,
when the Lord would send his angel of death -
the angel with the flaming sword that would cut
out the heart of each Egyptian family.

Rachel snuck out while her father was bundling
their few possessions, and her mother was
cleaning the remains of the tiny leg of lamb
they'd been given by their next door neighbor.

She moved quickly down the street, careful not to slosh
the blood in the bowl she carried. At each Egyptian home
she reached, Rachel dipped her rag into the bowl,
and hastily dribbled blood on the doorframe.

She kept on running into the dark, painting hope
on as many doors as she could reach, until
the dawn broke, and Rachel heard the first wails
of anguish from the homes further on down the street.

Mike Croghan is an accomplished geek, and has been working on becoming a poet for the past few years. By day, he writes code, which has more in common with poetry than you might think.

Anne Emerson

Blue Mist

Azure eye and emerald robe—
with gold-dust on your nose
and sweetness in your mouth—
you, with your many cousins all alike,
appear as soft blue mist beneath the apple trees.

My childhood orchard's sky-blue anklets
fill forever my mind's eye,
which sees, as well, a canvas by my mother,
where you live again—
blue on green
as though the morn's sky-tinted feather boa
floats among tall grasses.

I remember you—forget-me-not.

William F. DeVault

Sustenance

Life is not a privilege. It is not an option like spinning hubs or a boob job.

Life is life and we must sustain and protect life with the fervor and intensity

beyond politics and borders.

Poetry is food for the soul, but if the body withers, an empty stomach eating us out from the inside

poetry is embellishing the cancer of indifference.

Jesus fed the thousands. He knew words are not enough. Gestures hollow

as empty hands and ceremonial baskets are insult and perversion

of the ministry of necessities.

Sustain the children. The mothers. In Sudan, in Appalachia, in parts of the world

where don't really know about or care about because you have lost your soul.

Five fishes and a loaf of bread.

Not so much to ask.

William F. DeVault carries the twin sobriquets of The Romantic Poet of the Internet and the current National US Beat Poet Laureate. Author of over 25,000 poems, mostly focused on issues of love, sex, and identity, he has crafted a legacy in over twenty books and multiple CDs, as well as appearances from Boston to New Orleans, from New York to Los Angeles.

Robert Gluck

The Gift

I have a gift
I'd like to return
That allows me to see beauty
Then, before the awe fades,
I lift up the corner
To reveal the ugly underside
The old growth forest in stumps
The fish-strewn river spoiled
The native species overrun
By others hijacked from their homes.

I try dropping it
Re-covering the horror
But like a bandaged wound
I'm compelled to keep checking
Reminding myself
What it used to look like.

I don't want it
Let me give it back
No exchange needed
I'll be richer
When it's gone.

Nick Hale

I am not Afraid

I have nothing new.
No stalks of wheat
to paint the waves
in grain.

My story's finite.
walls cannot contain
the multitudes of what was ours
in name.

Time is awash in music.
Moments, like notes, hang frozen
suspended until we catch them
like snowflakes.
.

Our story, a forever beginning
that swallows itself.
Old Ouroboros becomes new.

Nick Hale is a literal and metaphorical hat collector. He is the vice president and a co-founder of The Bards Initiative. Originally a native of Huntington, Nick currently lives in Northern Virginia where he leads workshops and hosts readings and seminars through his group NoVA Bards. Nick is a publisher and editor with Local Gems Press. He has worked on many anthologies including the best-selling *Sound of Solace*. In addition to writing, teaching, organizing performing, and editing poetry, Nick enjoys reminding people that there are no bad jokes, only bad audiences.

Megan McDonald

Metal Muses

In the scream of metal wires
Notes are hammered free from
Metal muses. The empty buildings
Rise above a ghosted future.
In the dust of falling
Even rats are gone.
There is only the frames of iron
Rusting in the silence of cold wind blowing Hot hot and will not cool
down For the remainder of our earth time.
In the scream of metal wires
Notes are hammered free from
Metal muses.

Megan McDonald started writing in a junior high school creative writing class in Hawaii, but other than yearly Christmas poems did not start writing for twenty years. She credits her restart to poetry to an article in the Washington Post about a long running Virginia poetry venue. After attending a meeting of Poets Anonymous in 1995 she generated two poems and has been writing ever since. She has been published in Poets Anonymous (Virginia) anthologies, Poet's Anonymous (United Kingdom) anthology, Poetry Just for you, Event Horizon, Poets Domain and NovaBards.

Keith Munroe

Cake And Coffee

I watch poets in the café who can't read their poems without crying
and their poetry becomes a kind of prayer where the words need never
be spoken
yet through the aria of their tears they become candles in the wilder-
ness
and I wish I could move the crowd without the sorrows of my erudi-
tion
which guard against my need for mercy with its veil of wisdom
though nonetheless I carry on
and ponder people with their pastries, their cake and cold coffee
and try to imagine what empty breath of man starving in the streets
could find us here
and in that light tears seem more important than poetry.

So as I eat forkfuls of pie with its passion of empty promises
I remember that someone somewhere said good food is like the bread
of angels
and in that piece of wisdom I wonder if there is some quiet paradox
like a river of bleeding metaphor that lays its cooling water like a
cloak upon the shoulders of people as they read their silent poetry,
as though their mouths remain empty it is the cries of beggars that
give breath to the body.

So angels as they speak of heaven their wings will hunger for the winds of earth

because emptiness is the promise that bread gives to the philosopher with his yawning tongue

so though perhaps without currency a poor man watches other souls eat cake and drink cold coffee there is hope in the hollow and holy whispers of his longing breath

braced like aching bones against the walls of paradise where people come to pray

and think nothing of their bellies.

When I pass a man on the street I give him a dollar and feel like a bastard without offering him my flesh to give salt to his lungs

for why should I bear the sorrows of good fortune without his vagrant rags to stand beside me

and cloth me as I have cake and coffee, a man at home in the wisdom of his ignorance

where beggars cannot find me eating bread with its empty promises of heaven,

for what good is paradise without the brotherhood of all those in misery

so I give to all those who ask for food with sweating palms the sorrows of my aimless cries

which preach of love without the hubris that hounds the earth with its gaze of desperate pride.

Instead I look upon the clear waters of my passive jealousy and see in me some promise of forgiveness for the things which tomorrow seemed to promise in its whispers of eternity

but now pale in comparison with those who walk the streets without
bread to fill their mouths,
yet I believe there is hope in the hollow miseries of man as he like me
can stand alone
but find providence when together we hold hands against the shadows
of some sorrow yet to fall
like shimmering pearls upon our pale crowns of mystery.

What callow thoughts of nothing make palaces out of growing herbs
standing like angels against the water with its poetry of wind to make
vagrants of all our tongues sweating like weeping shadows in the sun
to build between us a brotherhood of souls
who share bread like the breath of heaven to weave stars between us
and make us wise with hunger that give to man his bond of empathy
for those too full of pain to make poetry from the veil of their lives
made private by the praying wounds of lands made distant in their
towers of philosophy?

Keith Munroe was born on November 26 1980. He lives in Northern
Virginia and is focused on studying philosophy and writing. He has
poetry published in previous *Poets Domain* editions.

Phyllis Price

Adult Education

In my forties I went back to school
to learn how human bodies work,
how cells rebel
and blood can clot or not,
how god-like genes
can twist our tongues
and curl our hair
and make us fat or lean.

But what I wanted most to know
was how the simple human touch
can filter light into a dark abyss
created by disease or too much thinking.
I longed to silence idle talk,
slip the body's armor off
and deepen shallow breathing.
Early on, I knew that flesh is holy,
just to be alive, sacramental.

Phyllis Price is a native and current resident of Blacksburg, VA . Her writing is rich in imagery and focuses on celebration of the natural world and growth and renewal of the human spirit. A love of photography is a source of inspiration for her writing. Prices' most recent work is the chapbook *Quarry Song.* Other works include the book, *Holy Fire, and* inclusion in anthologies and literary journals and periodicals.

Lesley Tyson

imaginative cooking

i'm supposed to be researching
creative recipes for chocolate chips
no cakes cookies or ice cream please
but i find myself running my finger
along an old business card
from a purveyor of goat cheese
that makes me think of the goat
on a windowsill next to a vase
of purple daisies in a blue stucco house
sitting in warm sun on a cobbled street
somewhere upside down from here

i imagine it seldom goes dark there
and i'd be overdressed for that climate
i wonder how i'd store chocolate chips
even as i lick their last trace
from my fingers

Lesley Tyson from Reston, Virginia, has had work in issues of *The Poet's Domain, NoVA Bards Anthology*. Lesley is a regular contributor to several local Northern Virginia poetry groups and co-leads *Poets Anonymous* ©, Northern Virginia's longest running open reading.

WISCONSIN

Mary Jo Balistreri

Ancient Ritual

Dad, in his long blue robe
and thinning steel-gray hair,
enters the spotless kitchen
in worn-slippered feet.
Shadowed dawn
announces its presence,
releases the closed petals
of sleep to the templed rhythm
of a new day.
Dad opens the cupboard,
carefully removes a cherry-blossom
plate—his mother's best.
Setting the breakfast table,
he arranges the porcelain dishes
just so, creates a spring garden
at each setting forever green,
each branched bloom reaching
toward light.
Like a Buddhist monk, he walks
within his life,
treads slow measured steps,
gives attention to each detail
as if it were new.
He pours brewed tea, concentrates

on the steady stream pooling
in the bone-thin cups,
follows the steam
as it drifts upward like incense.
This ancient rite of morning began
in my childhood, and I watch again
as Dad walks to the draped window
to pull open the day. For a moment,
he will stand enfolded in mountain sun,
before he turns to me and says,
Isn't it fine.

Mary Jo has two books of poetry published by Bellowing Ark Press, a chapbook by Tiger's Eye Press and a new book due out in September, 2018. She has read her poetry for every event held for the Food Pantry in Waukesha, WI. She is one of the founders (3) of Grace River Poets, an outreach for school, churches, and women's shelters. Please visit her at maryjobalistreripoet.com

Sylvia Cavanaugh

Mount Joy Homeless

Solitary car dweller
rocked-out drop-out
once galloped alleyways
of honeysuckle summer

we were all storytellers back then
and he most of all
his exuberance would spin colors of taffy
to fill your mouth
cling to teeth the way we clutched our sides
in unbearable laughter
or like his butterflies pressed
under plates of glass
traced with fingers
he'd understand my impulse
to write this story
from my Midwestern prairie desk

of the unhinged Oldsmobile
just outside Mount Joy
left in the thicket of hemlock
beside November's chilly creek
as a boy he chased butterflies
through July's bright shimmer

and in his mind at night
tracked them to rocks
and fallen ledges
fairy hollows and mossy places

winter's first flakes
press down on the backs
of evergreen branches
as they reach wide their tips
in graceful downward arc
alight with the weight of white

fifty three
alone in an abandoned car
tumbled from the flanks of joy
rusted blood slows its course
clutched in the metamorphic heat
of snow

Originally from Pennsylvania, **Sylvia Cavanaugh** has an M.S. in Urban Planning and currently teaches high school African and Asian cultural studies. She and her students have been actively involved in the Sheboygan chapter of 100,000 Poets for Change. A Pushcart Prize nominee, her poems have appeared in numerous publications. She is a contributing editor for *Verse-Virtual: An Online Community Journal of Poetry*. Her chapbook, *Staring Through My Eyes,* was published in 2016.

Joan Marie Giusto

Timeshares

When we catalog
lifetimes
we mark them
by first times,
last times,
and one times,
but the most
telling time,
of all
is
all
the time
between.

Joan Marie Giusto lives at the end of a road on the edge of a lake in the northern woods of Wisconsin. Her poetry and prose has been included in various journals and anthologies.

Heidi Hallett

Modern Mermaid

When manatees were mermaids,
Mermaids were once
Iridescent and mysterious,
A haunting wisp of sea-tale.

But manatees were found,
And our ancient mermaid lost.
No more shining mystery,
Or silken hair, or sparkle fish tail.

How about then a modern mermaid?
Liaison in place of siren
With bronzed hair and a dolphin tail,
Or a soothing voice, or wild white wings -

Or whatever it takes to touch base
And bridge space.

Heidi Hallett sees creative expression through poetry as a way to collaborate and converse with others. She finds that poetry enables us to examine and appreciate life, and she enjoys working with the imagery in poems to explore an idea. Heidi is a small animal veterinarian who paints with oils as well as words, often using these two mediums to complement each other. To find out more, please visit www.aquaartideas.com.

Pat Janke

Mother

If I were Mother Earth for a day
I'd get down on my knees to pray
For this planet turning grey

Breathing fresh air becoming rare
At high pollution rates I stare
People screaming life isn't fair

Population growth unsustainable
Clean water for most only a fable
Less food found on our world's table

War destroys ancient treasures
Civilizations destroyed for pleasure
Earth's ending being measured

Khristian E. Kay

Favorite Roads

My Favorite Roads are ashen
a chalky white of patched
and cracked arthritic asphalt
aged and bleached
There is no centerline
no paint no makeup just
raw flesh under a midday sun
No defined lines limiting access
but rather following the collective
observable rules
of good conduct and neighborly
jurisprudence
specifically for the polite travelers
the vagabonds trespassing moments
These are not the shiny black roads
the glistening stars light on a sable curtain
These are lifelines like varicose veins
warped and stoic and telling
The Braille staccato of farm implements
and tractors of horses and bikes and
children skipping couples walking
over the sticky tar patches
plastered like gum or pine sap in

the crease of wounded trees
These roads tell stories
experienced and weathered of time
and life of legacy and inheritance
of history whispered through the wind

Khristian E. Kay is a writer and a K-12 educator who resides in Oconomowoc, WI. He has written several books of original poetry which can be found here: www.khristianekay.com. His work often appears political and satirical he utilizes words as metaphorical rubber bullets: painful, bruising and only lethal at close range.

Fred Kreutz

Grandpa

Grandpa wore his jeans neat and trim
unfaded, clean and crisp,
big pockets in the back.

Wore his shirt clean and trim too,
long sleeved, two folds up on the cuffs
enough to show his muscular arms, sun tanned from outside work,
his hands muscular and lean.

Wore his white hair and beard neat and trimmed,
just long enough to run a comb through,
haircut every two weeks, same day, same barber.

Grandpa was mostly silent, but could he sing,
sad songs, silly ballads, love songs
strummed his guitar, crooned grandma,
glistening stars in his blue eyes
that matched his neat and trim jeans
big pockets in the back.

Fred Kreutz is a lifetime teacher, photographer, and writer. His poems have appeared in Farquier Poetry Journal, Little Brown Poetry, One Vision (Lake Country Artist and Poetry Project) 2009 and 2011 and Blue Heron Press. He likes to find surprise in each poem, an energetic interplay with words and sounds, and hopes each reader sees something new in each poem.

Janet Leahy

The Cellist of Bagdad
Karim Wasfi, former conductor
of Iraq's National Orchestra

The deep low tones of his cello
a counter point to the ache of grief
that settles in the scorched wreckage
of an outdoor market
a cemetery
a bombed out cafe.

Soldiers tell him
his music makes them
feel human again.
He plays at an orphanage knowing music
will help the children heal.

More than twenty years ago
during war in Bosnia
the Cellist of Sarajevo brought music
into bomb shelters,
to funerals,
 to the burned-out library.

The madness of war repeats
strings of the cello tremble
in witness.

Janet is a member of the Wisconsin Fellowship of Poets. She has published two collections of poetry: *The Storm, Poems of War, Iraq* and *Not My Mother's Classroom.* Her poems appear in The Wisconsin Poets' Calendar, literary journals, and anthologies. Recently her poems won second place and honorable mention in the Wisconsin People and Ideas poetry contest. She lives in the Milwaukee area.

Cristina M.R. Norcross

Breaking Bread with Chicken Booyah

We sat on wooden benches
while the steam from chicken broth
left the air humid –
a rich, golden scent.
Margarine containers for bowls –
just enough to go around.

Each child's name started
with the letter J.
They had fourteen to feed,
plus our family of four.
This was generosity.

The youngest daughter
touched me on the arm,
"You wanna watch my
sister get her ears pierced
with a needle, a potato
and an ice cube?"
I nervously smiled –
not knowing if this was
a serious question, but
secretly thrilled
that I was invited to a sisters-only

ceremony.

There was bread
and broth
called, chicken booyah.
It was a true welcoming.
Soup, warmth, conversation,
and talk of sharing recipes.

This is how you greet
a neighbor –
with a chair pulled out,
napkins laid on the table,
and the knowledge
that you are home.

Cristina M. R. Norcross lives in Wisconsin with her husband and their two sons. She is the founding editor of the online poetry journal, *Blue Heron Review*, and the author of 7 poetry collections, including *Amnesia and Awakenings* (Local Gems Press, 2016) and *Still Life Stories* (Aldrich Press, 2016). She is the co-founder of Random Acts of Poetry and Art Day. www.cristinanorcross.com

Diana Randolph

Cosmos Flowers

The hard, firm buds
appear to be content to remain closed-up.
Perhaps it takes the ethereal garden fairies
to alight on top of their stems,
coaxing them to let go of their safety,
to open and expand, facing the outer world,
to flutter under the vast blue heavens,
to sway in summer breezes,
and to balance raindrops on their petals.
For then they will truly be complete,
radiating their potential to the universe,
becoming the essence of the Cosmos.

Diana Randolph, Drummond, lives in the midst of Chequamegon Nicolet National Forest in Northwest Wisconsin where she loves participating in silent sports – cross country skiing, hiking and running; and growing flowers and vegetables in her garden. She is the author of Beacons of the Earth and Sky, Paintings and Poetry by the Natural World (Savage Press). For more information please visit www.dianarandolph.com.

Liz Rhodebeck

Giving To The Poor

Be not forgetful to entertain strangers: for thereby some have enter-
tained angels unawares.
 Hebrews 13:2

When I shop for the food pantry
I resist the urge to buy the
four-cans-for-a-dollar vegetables,
choose instead the really good kind, what
I would want to eat if I were hungry,
and had no choice but to accept
the handout of a pre-packed box.
I pick carefully, I hope, realizing the poor
could be my startled old classmate in the line,
and I wouldn't want to be ashamed
if I served her less than
what I'd set before her at my table years ago,
when the possibilities of the future
seemed boundless--except this: her standing in a line,
me behind the counter, both of us awkward,
as I furtively search the shelves for the best,
morbidly curious how she ended up here,
reluctant to ask myself the same.

Liz Rhodebeck of Menomonee Falls, Wis., is the author of three chapbooks including *Here the Water is Deep* and *What I Learned in Kansas*, and is a founding member of Grace River Poets. She recently mentored and edited the anthology, *Hear My Voice: Poems of the Unheard Girls from the House of Love*, a ministry that serves teen girls in foster care in Milwaukee.

Her website is www.waterwriter.com

Jeannie E. Roberts

Weathering Her Conditions

> "In the midst of winter, I found there was, within me,
> an invincible summer. . . ." —Albert Camus

Beneath the thatched catch of palm,
dried leaves veiled the yawn of privilege.
Sipping gin in the tonic of exemption,

you remarked: *I realize I'm just your*
fair-weather friend. Though your
nonchalance chilled, killed warmth

with toboggan-like force, I hung on—
for in the drab grab of winter, my
forecast remained the same: steadfast

with a slight chance of doldrums
midst mostly sunny skies. And now,
after nearly a lifetime of weathering

your conditions, I've let go. Holding
my own, I slide gracefully, warming
within the weather of an unconditional

friendship, having embraced myself
within the internal bosom of my invincible
summer.

Jeannie E. Roberts's fifth book, *The Wingspan of Things*, a poetry chapbook, is forthcoming from Dancing Girl Press. She is the author of *Romp and Ceremony*, a full-length poetry collection (Finishing Line Press, 2017). She writes, draws and paints, and often photographs her natural surroundings. Learn more about her at www.jrcreative.biz.

Sara Sarna

On the Silver Screen

I want to live in an old black and white movie
Where evil and good are the black and the white
and the film is a thousand variations of gray
at twenty-four frames per second
The good guy wins
and the bad guy gets his just reward
but there is always a chance for redemption
though only the hardboiled reporter sees it
Men know how to dress for success
and women
just flat out know how to dress
The quality of light flickering on the screen
barely changes when they shoot day for night
and you can tell what's coming
by the change in music
but you hold your breath and lean
slightly forward
just the same
The reporter smokes, the detective drinks at lunch
and Mr. Right is waiting patiently at the end
when the handsome wise guy proves unworthy
The silver screen makes me feel rich
as the overture reprise plays my happy ending
into the credits

Sara Sarna is a Patient Services Representative at a large health care organization, but the work of her heart is as a wife, mother, actor and poet. She grew up a military brat but settled in Wisconsin in 1993 and thinks she'll stay awhile.

Jo Scheder

Maladies

In a snowy university town
a small team exsanguinates mice
drafted for interventions
superior to quinine and DDT.

Months of monotony and slush,
endless assay protocols;
mundane precision
numbs the passion.

Latitudes away in tropical heat
villagers shiver, swatting
as efficient Anopheles
deliver P. falciparum.

A flutter of thin eyelids
languid against the heavy noon
silence fills the air that held
a father's laughter

A child smoothes the cloth that carried
a mother's dreams
an uncle rolls the mat that hummed

a grandmother's songs

Disposable, like the plastic tips of pipettes
latitudes away

A flutter of publications,
languor of multi-year grants,
tedium and technicalities,
never shivering in tropical heat.

Jo Scheder began exploring poetry as alternative ethnography following a career in anthropology. Her poetry is included in *Verse Wisconsin*; *The Ariel Anthology*; *Echolocations: Poets Map Madison*; *HYBRID: Transported by Word and Image*; and Poetry Jumps Off the Shelf's *Up to the Cottage* Project.

Paula Schulz

Still Life, Spring Flowers

This still life shows flowers in a vase as
white fingerprints and small melon colored
paint smudges pushed into darkness. They hold

the light the way you hold a thought in your mind:
without really holding it. What looks like
an aqua chalk line is a glass vase

holding stems that must be sipping sun along
with water since each stalk wears white-yellow
streaks, and carries this lively current

into the firework of blossoms. That
Morse-code dash of glow at the water line
a warning: this field is electrically

charged. Static sparks like sequins, scatters
and hovers over the painting's surface. It
gathers among petals which give back the light

that opened them to the joy of their bodies.
The frame's gilt edge and the bright-quiet
image it holds: this shining moment,

this life,
this beautiful, fragile
now.

Ed Werstein

Wheat Harvest

What I wouldn't give
to climb up the side of my uncle's truck again
on a hot summer wheat-harvest day
to lean over the side board
and let the combine hopper
pour its payload
through my spread fingers.

To take a kernel into my mouth
and bite into it like Dad
to test for moisture,
to know we had the perfect day,
but still worry about finishing
before the evening storms
that always hurry after heat like this.

To cart jugs of iced tea and Dixie cups
from house to field for the men
and to be a little part
of that great harvest scene again.

Or to watch Grandpa on a Saturday afternoon
small ax in hand,
select the chickens for Sunday dinner,

to help Grandma pluck on the porch.

It's not just the being ten and innocent again.
It's to know again where things come from,
that someone's grandma fed the chickens I eat,
that a real human being touched the wheat
in my bread,
to know the name of the steer
whose meat is in my freezer.

To be able to think once more that vegetarians
are a little strange.

To have never heard the word agribusiness.

Ed Werstein, a regional VP of the Wiconsin Fellowship of Poets, has poems published by Stoneboat, Blue Collar Review, Verse Wisconsin, Gyroscope Review, and others. He has had several poems anthologized. His chapbook, *Who Are We Then?*, was published by Partisan Press.

CONNECTICUT

Andrea Barton

Absence is a Long Word

This is part of what I know:
Absence is a long word

That can gather itself
Into a wave curling

Around and cupping nothing,
Slamming the coast

Of my chest, carrying out
The little loose stones

Each swell
Its own storm

Leaving froth in its place.
This is the part I don't know:

What is this aftermath,
The foam on the shore;

Your breath? A memory?
It turns to nothing in my fist.

Andrea Barton is a mother, a daughter, a poet, and a teacher, in that order. Her work has appeared in publications such as *The Labletter*, *The Cleave Webzine, Broken Publications,* (a journal of domestic violence,) and *Haiku Journal #42*. Andrea has taught Creative Writing, American Lit, and Communications at RHAM High School in Hebron, CT for 20 years, but her greatest achievement to date is her 13 year old daughter, who is still bright and lovely and sparkly, despite her adolescence. Andrea and her daughter live on 4 acres of ticks and spiders and yard work in Glastonbury, CT.

Jasmine "Jazz-e" Eaton

I Have To Teach Her

Jazz-e and j.j.
mother and daughter
on this journey together.
Our bond will last forever.
I've learned my lessons the hard way,
My head is rock hard
I learn through regret and shame.
I want to pass my wisdom to my legacy.
Hoping to pass her immunity.
So she is not shrouded in shame… like mommy.

I have to teach her… .
j.j.
you are so beautiful
Sweet and soft
like honeysuckle,
Like cashmere
Brilliantly, beautiful like a high-class chandelier.
Baby,
in this society,
you can't be
JUST beautiful.
You must be smart and strong too.
I don't mean strength from lifting weights.

114

I mean strength to lift your self up
when life knocks you down.
Most High and I will teach you
to have rubber band resilience.
So you can go the distance.
I have to teach her ...
-character-.
You reap what you sow
So,
Sew **love** into the fabric of your soul
Sow integrity seeds.
So you can reap
Values needed to succeed.
I have to teach her...
before you speak,
T.h.i.n.k.,
Keep your words:
True,
Inspiring,
Necessary and
Kind.
Keep the golden rule in the forefront of your mind.
Speak you mind.
Mean what you say.
Say what you mean.
Don't react ferociously
Let the female dog in you mean:
"Bright
Intelligent,
Tough,

caring and
Honest."
I have to teach her,
The significance
of the Egyptian sphinx.
A human head superseding the body of a lion.
Thought and reason over
animalistic passion

there is love
and there is lust
big difference between the two.
If you overly expose your body
Expect to attract someone that lusts for your body.
Don't give up your precious cookies too easy.
Some men equate scantily clad to - easy.
Put your brain on display.
Not your boobs or your booty
Flaunt intellectual
Not sexual beauty.
I have to teach her...
With Perseverence!
you will be victorious.
Keep trying! Don't quit!
The rainbow's awesomeness
Comes after a stormy mess.
Spring flowers follow
Winter's frigid finesse.
Even a budding rose struggles to make progress.
Remember…

Mommy is always here.
No matter how busy I am.
No matter how tired I am.
No matter how small the issue.
Mommy is always here.
I am your lighthouse at the end of the pier,
When the path home is unclear.

Ernel Grant

I got the "It"

I'm not one of those knock you off your feet gorgeous like Edris Elba or one of them peeps; but I can hold my own

I'm not one of them over 6 feet tall and ripped like Tyson Beckford kinda dude; but I have a lil something to hold it down

Might not know or even care about a lot of these new artists of today; but I still know a lil something about good music & soul

I'm not one of those bottle poppin' ice wearing, name brand slaves, doing it large kinda fellow; I walk around clean, head high with a nice Jamaican ditty-bop keeping it mellow

My confidence scares them, it fuels them, to always try and keep me down...they don't want to see me take my rightful place at the throne, yo, back up and gimme my crown

They plot like the Secret Service, they use pawns to do dirty work, they try their best to hinder but my defiance will continue like Shaka Zulu

So I walk with a swagger in the midst of this covert persecution, you're no longer in the dark, the light is shining on you

I got the "It"

I'm not one of those well off dudes raking in the doe like LeBron James, but you couldn't tell me that I'm not one of the richest men in this world

I'm not one of those tough guys like Sylvester Stallone or Brue Willis; but come at my family and that hardcore fella will definitely surface

Blessed to make it this far without jail time, got a decent education and the chance to experience true love

Statistics says I am very lucky to reach this age, a chance to have gray hair & a family and friends who make me happy

Don't have dollaz rolling out the ass, no IRA's or inheritance; but I glide down the streets with head held high and self-assurance

I have the chance to touch and influence the masses

So I am blessed and got the "It"

Yeah I got it

Dori Green

Infinite Wolf

Slipping on its skin of steaming breath and brawn.
The creature climbs the rocks to find enlightenment in early dawn.

A hunger lingers
as the tribe howls
and dances in the moonlight
as limbs gather fingers reaching in from the timbers.

That knowing
of ancestral lineage, genetic spirals,
and ancient wisdom creeps, vibrates in the pads of the feet,
as they move to the beat. Softly with a purpose.

Distant drums hums
and sparks like fireworks and crashing water,
like lovers,
like divers,
like birth,
and death.

Again we swoon and sway, again in distant days
and ways that transcend and befriend
the mundane
and the insane.

A calling
a ritual
an exhausted tomb
that vibrates the womb
and brings it-self forward.

A child reaches out
to touch a beast
and becomes a friend
in grey areas
grey matters
mind open
and expansive play.

Vincent Vangough
would be proud to know
he tapped in
and could see
the unseen.

Repeating swirls unfurled
Unfettered longing to be
Something more
Than ordinary

Glowing over river stream and blaze of lights,
stars on low horizon slipping down.
The chariots on fire
from the heavens

bring a message.

The time is now
kindred hearts,
to impart
the knowledge
to hear the voice,
to see the glow
and shine.
Do not take it
to your graves
the salt the sea
the craving of stars
of gods and light.

Howl at the moon
little ones,
be dust and glitter
in the almighty room,
find your way through seven doors
to the things
you have known before
but somehow
lost your way.

The herder
in wolfs clothing
gathering his sheeples
to the steeples
to the towers,

to the churches
to the tombs,
to the rooms
of songs recording,
creating the
tap tap boom,
and the one two, one twos. Where the wolf
and sheep sleep
in rhythmic slumber.

Where are you sweet Rose? Are you under foot
or under the stars
and moon
swooning over
the big big love
of small things
in infinite places…

A finite life
so filled with love.

She had to paint it.

Dorraine Green has been a CT poet enjoying writing since age 14 for some small publications and as a spoken word performance artist. She paints and enjoys other arts both in the healing profession and for creative pleasure.

Colin Haskins

The Beast of Franklin Swamp

Prowls the detritus
Of failed farms
Broken framed
Dentistry of
Twisted cages
Manmade ponds
Dark barked trees
Coattail reeds
Peers through leaves
Smells your fears
Walk and it hears
Your loud crunching
Steps on the paths
Watches as you pass
And follows
Close behind

Wander off trail
Or linger too long
And you might
Not ever
Be seen again
The cause of
Your missing

Inconclusive
At
Best
Or
Beast

Colin Haskins is a poet, writer, author & event promoter who for 30+ years has been creating venues locally, nationally, and worldwide, bringing poets, authors, artists, and musicians together to bring poetry, music, art and culture to many different national landmarks, museums and historical locations. Colin is Co-Founder, CEO & Executive Director of National Beat Poetry Foundation, Inc. and Founder of Free Poets Collective. He also co-founded the Connecticut Beat Poetry Festival and National Beat & International Beat Poetry Festivals. He is the published author of 6 poetry books and is currently working on two new poetry books.

Debbie T. Kilday

Photographic Dreams

Dreams

Do not expire
They flutter through time
With never ending desire

Flashing past
In a blink of an eye
Like undeveloped film
Never printing the photograph

Dreamweaver's
Visionaries with creative souls
Open minded champions
Of the underdog
Seeing only the best in others

Dreams & Dreamweaver's
Floundering through time
Trying to find
Depth of perception

Looking through
Wide-angles lenses
Shuttering through life
Giving a revelatory feel
As one compliments the other

Debbie Tosun Kilday is a writer, award winning published author, poet, nature photographer, artist, illustrator, graphic artist, and an expert high-roller slot player. She is the owner, Co-CEO, and Executive Director of the National Beat Poetry Foundation, Inc. and part of the National Beat and International Beat Poetry Festivals.
Debbie is Special Events Director, and Past President of Connecticut Authors and Publishers Association, (CAPA) She is also a member of Free Poets Collective, and University of Connecticut's (OLLI) Osher Lifelong Learning Institute's Hydropolis Poetry Group She is currently working on two books, one is an erotic romance and the other is a How-To book on playing slot machines.

Michael Kilday

Throwaways

An army of homeless, the dregs of Society
Throwaways march in broken rhythm on concrete
Bark their tourette's syndrome monologues
to whomever might be listening.
They served old Glory on the battlefield,
But now they do recon missions in the urban brush,
Probing the darkest recesses of the usurer's soul.
A storm front of tortured souls,
Former brothers-in-arms, suffering in unison
Silent testimony to the failure of the American Dream on paper
Begging from the haves for their daily bread
Their tin cups rattling with nickels and dimes
The haves rush by sensing something to fear,
From those who have nothing but the rags on their backs
A callous system chucks them aside
And steps over curled-up carcasses in the doorways
They have to pass through,
Wishing them away like a bad dream.

The gap between haves and have-nots widens each day.
The middle ground recedes like low tide.
The ranks of the overpass dwellers swell in numbers
Like the pigeons who roost underneath
Soiling the ground with their droppings.

Throwaways stain the concrete barriers with urine rain.
The have-nots gobble up the refuse of the haves
Like street crustaceans performing their duties.
The rattle of trash cans bear witness to their meager fare.
Cockroaches swarm when the lights go off.
Past the stares and tsks of their betters,
The holier-than-thou who are fortunate to enough
to be doing the judging, instead of being judged.
Pissed off they have to weave a way on the sidewalk
Through the dogshit and bubble gum

City streets are crowded with human refuse
Throwaways that refuse soup kitchen mercies
To sleep on beds of macadam and tar
They reproduce like insects in the urban swamp,
Acquire their shopping carts and learn the aluminum can trade.
Ladies and gentlemen flaunt their ignorance by looking past
The filth and squalor of the great unwashed
And wish their leisure time was spared such a sight
When they go out on a Saturday night to dine.
Politicians offer bars of soap and running water
To avert the embarrassment their neglect made.
But it is too little, too late to stem the tide,
A cavalier gesture of pointless compassion
for those who they say have chosen their fate

The night is filled with the bustle of urban animals on the prowl.
A savior squats behind the dumpsters in the alleyways
A denizen of the doorways that sleeps standing up

Who has dropped out of the rat race to live off the land,
would rather have a blanket to lie on than salute a flag and stand
His contempt for the haves displayed in flashing the bird
At heads turned away from the grime
Grumbling under his breath – master has no shame.
Urban messiah strategizes a plot upon a throwaway society
whose castaways will get their revenge
When the park-mentality reaches fever pitch.
The discarded pets will turn on their masters
And will not hesitate to bite the helping hand.

Michael L. Kilday is a 1972 graduate of Boston University with a Bachelor of Science degree in English Education. He has worked as a high school English teacher, journalist, and for 36 years as a software engineer. Now retired, he has written four non-fiction books and folios of unpublished poetry. His poetry focuses upon topics of a sociological, political and spiritual nature exemplifying an independent voice crying out of the wilderness of self. One of his non-fiction books, A Yippie's Lament, received the CT Press Club first place award for non-fiction in 2013.

Jessica Brooke Miller

Birdcage

Staircases never ending
No way out to freedom
Desiring to fly
Yet my feet cemented to the ground
Frustrated instead
I cry

Trapped as if a bird
Outside is a courtyard
Yet it is a cage
Freedom is beyond reach
A tease
I get out only to knock to get in

The irony is seething
Like a poker fiery red
Searing into my brain
It's pouring out
Yet the fire is never quenched
Burning bright is my spirit
Still here
Still here

Trying hard to drag me down

This brick cage within I am trapped
Panicking, I flap my wings
Refusing to suffer any longer

Suddenly there is hope
I see daylight through the cracked mortar
I lay my indigo wings flat
My inner light bursts forth
Bricks crumble to dust in my wake
In the shadow of my strength

SwanTina Monet

Life is Love, Life is Beautiful.
Life is living each day and recognizing the love
and beauty within yourself and the world.

Friendship is the key that opens the door
to the real self within; that creates that special relationship;
opening that bud to blossom into love and passion.

In my search, if I do not find the love of my life;
then what is more rewarding than a real friend for life.

If we tell the truth, develop and enhance an open voice with each
other;
we can share a "new beginning" that will endure a lifetime.

Clementine Gant, aka: SwanTina Monet is a Poet, Spoken Word Artist and Creative Writer. She is an Educator with the Hartford Public Schools and resides in West Hartford, Connecticut. A graduate of Western Connecticut State University; she earned a Bachelor of Arts degree in Communications / Theater. SwanTina expresses that words are very powerful to her and they become a melody in her thoughts. These thoughts become the sound of music, creating a dance all over the pages to the tune of poetry.

Rebel Poet

El Poet

His steps are Rumba,
Morning Guajira,
La Clave runs through his veins
There's Montuno ingrained
In every strand of D.N.A
Fresher than
New school clothes on the first day,
Arawak Battle-axe
Bomba y Plena Bodega sway,
Revolution to the institution, in fact
Machetero cocked back Native tongue,
Pionero, Vocero, Orator on the run
Watch that, Ricochet Cadence word-play
Impact, causes line breaks;
Titere style, Jibaro smile,
New York City Stanza
Creates a Nuyorican
Freeverse make you dance
Ese, El, Oye! Thunder when he speaks,
Essence from the elements he keeps
A brolic Sonnet, listen to the beat!
Find him painting pains portrait
Hypodermic pen,

Blood stained canvas
Spilling from within,
Abstract realism
Real is him!
Penmanship
Sends visions
Down your stream
Of consciousness
Conscious vivid, flash sparks,
Flashback sparks are Moondust
Cosmic gunpowder,
Partitioned data
From past cycles
Magnified Megaton explosion
Coming from fertil fetus,
To defeat us is inconceivable!
In conceiving possibilities of proximity
Measure the time it takes light to travel
From such distant objects
The him that's seen is Her,
Majestically becoming divine, refine
Instantly accessible to find
As one being whole, being old soul
Lingering, literal lyricist,
Theme tension activist
Black Ancient fist,
Disclaiming Academia!
The Social Movement before the media
Before before, before there was a before,
They are more

Created Self out of Triple Darkness
Exhausting all eons
With a single thought,
Defining all explanation of reason
Echoing in every Season
Seasoned eloquence,
Perfection of motion, reflection of to be, to be, to be
El Poet is She.

Jimbo Rific

Coats on the Bed

I yell
Honey they're here
Be right there

Brushing her hair
Smiling at the photo
On the mirror
She covers her face
To cry out laughing

All at the same time

Through the hall
She tilts the
Picture perfect
Fixes her skirt
Then kicks the
Rug correct

All at the same time

Her smile rolls
Out the red carpet
Welcoming family of friends

For fun
With hugs
Kisses
Pats on the back

All at the same time

In the kitchen
She whips things up
Taste testing it
Just right
The laughs
Get louder
Remembering when

All at the same time

Leave it till morning
Off with the lights
Snuggle each other to sleep
Dreaming how nice
It was having
Everyone here

All at the same time

Jimbo Rific digs the beatnik scene, writing latenight poetry and prose. His influences are R. Crumb, Charles Bukowski, The Beatles, then leaves room for his friends.

INDIANA

Jennifer Criss

Red Clay

Her mother told her once
that all life's secrets were hidden
in Mother Earth herself.
But here she was, wrist deep
red clay caked beneath her fingernails
and cheeks stinging with tears.
She came up with nothing.

Jennifer Criss graduated from Ball State University with a minor in Creative Writing and is currently working on her second degree. Her poetry has been published in Poebita Magazine, Whispers, The Poet Community, NY Literary Magazine and Indiana Voice Journal. Her work also appears in several print anthologies. She was nominated for a Pushcart Prize in 2016. She now works at Ball State, is a busy mother of two girls and the art editor at Indiana Voice Journal.

Katelin Rice

Golden Daughters

Who graced King Mitus with the touch to conceived
golden daughters?
Are your pockets anchored with snow?
If I tug at your horns will you close in around my neck?
Does comfort come in a size medium?
When will the doe drown in the foam?
In the end, will you protect me from the fangs of hour-glasses?
Where will the sky meet my fears?

Katelin Rice is a mother, wife, feminist, and yogi. She studied English Literature and Creative Writing at Butler University, and she went on to receive her Master's in Education. She currently teaches middle school Language Arts in Indiana, and she directs her school's drama program as well as coaches the English academic team. Rice spends her summers teaching at Butler University's Creative Writing Camp.

Luke Samra

Trace

There was a man who wrote all the
Answers to life in the sand
But the waves washed them away

In winter, he wrote love notes.
In the snow, the sun melted
The message

His lover wrote on his back
With her finger
She spelled out "I love you"
And that would always linger

Luke Samra resides in Indianapolis, IN. He is a tennis instructor and musician. Luke has been published in: The Flying Island, The Tipton Poetry Journal and FishFood Magazine.

Stacy Savage

A Stroll with Mother Nature

Following a day
Of much distress,
We began to walk
And not obsess
Over our problems
We tossed aside
When Mother Nature
Became our guide

Along a path
Through her lovely home,
Where dragonflies dart
And bunnies roam.
She gilded a beak
Of a bird in song—
What a tiny fellar,
But a voice so strong!

Sunshine spilled over
Into silken threads,
Where weavers rested
Within their beds.
She led us to a view
That mirrored the lake

Where fishermen relaxed
And enjoyed a break.

Then we followed
To a gaggle of geese.
All along the path,
We admired the peace.
A blackbird with patches
Of red on its wing
Flew front and center
And began to sing.

My spouse noticed flowers
At the very end.
"It's the daisy trail",
He said with a grin.
Thanks, Mother Nature,
For the tranquil stroll.
O, how Summit Lake
Doth soothe my soul!

(Stacy won Summit Lake State Park's 2016 nature poetry contest for this poem.)

Stacy Savage enjoys mixing poetry and good causes together. She runs a Facebook page, Poetry Contests for a Cause, where she posts her calls for submissions and contests. She organized a Bards of Hunger event in her hometown of Anderson, Indiana in fall 2016. Her work has been published in numerous publications, including Birds and Blooms magazine, Ideals Magazine, Asian Geographic magazine and The Avocet.

Maik Strosahl

Someone Left The Door Open

Someone
left the door open,
let the days blow through,
across the dining room and down the hall,
out the broken glass of a bedroom window.

Someone
let the paint chip,
hung up on the siding salesman,
and let naked boards turn gray,
losing their teeth to rot.

Someone
let the shingles rain to the yard,
left storms trickling through the house,
washing away all the
pleasant memories of youth.

Someone
pulled out support beams,
took a sledge to the foundation
and never turned around,
never even paused to look back

at the rubble of our collapse.

Michael E. Strosahl was born and raised in Moline, Illinois, just blocks from the Mississippi River. He has written poetry since youth, but blossomed when he joined the Indiana poetry community. He has participated in poetry groups and readings from all parts of the state and at one time served as president of the Indiana State Federation of Poetry Clubs. Maik currently resides in Anderson, Indiana.

FLORIDA

Denise Fletcher

The Weary Travellers

The weary travellers
 dot the landscape
Transplanted
 like wild flowers
Waiting
for a meal
Listening
To the preacher
 Strumming his guitar
Toothless and ragged souls
Tattered hair
Holes in their shoes
Hungry eyes
Fixated on the food
that fills the belly
Making plans but
 fearing tomorrow
Scraping houses
 for daily labor
Displaced
 Cursing their fate
Hoping
for a fair wage
Dreaming

of a soft bed
Instead
Collapsing
On a tarp base
 Over matted pines
Bruised and broken
Searching
for respite
from wind and rain
In need of protection
 from danger
of bodily harm
The Sun shines on
the steeple
 pointing the way
Welcoming
 The weary travelers

Denise Fletcher is a freelance writer. She received a B.S. in Recreational Therapy from Minnesota State University, Mankato. Her creative work has appeared in Drabble Quarterly, Praxis Magazine, Open Minds Quarterly and other various publications in the U.S., Canada and the U.K. She is the author of the chapbook, "A Thread of Hope." She currently resides in the Tampa area.

Larry Jaffe

Today I had nothing

Today I had nothing
except the scraps
of food scraps
that no longer
stick to bones
or builds bodies
in any way.

Today I had nothing
perhaps I can fashion model
the skin and bones look
is in this year…
but there is no runway
for models
or airplanes
there is no leaving
except as ancestor.

Today I had nothing
the cold is vibrant
but does not make you feel alive
our clothing a patchwork
carnival of cloth
that barely gives shelter

we all look alike
males and females
heads shaved
for the wig factory.

Today I had nothing
the bricks of the walls
do not show the
tears that built it
the wind never
stops howling
there is no justice or mercy
only cracks in concrete
to remind us of the frailty.

Today I had nothing
and wonder why me
and ask god for forgiveness
if he would just set me free
I would believe in him
instead I watch others
look for signs and omens
betraying god's existence
or is it his ignorance.

Today I had nothing
and realize I feel
spiritually barren
my faith no
longer good company

I rail against a god
that no longer exists
I would gladly trade
my dignity for food.

Today I had nothing
even the muse
left me and
I can no longer
write in blood
on these walls
my blood has gone dry.

Today I have nothing…

Larry Jaffe was the poet-in-residence at the Autry Museum of Western Heritage, a featured poet in Chrysler's Spirit in the Words poetry program, co-founder of Poets for Peace (now Poets without Borders), and was awarded the Saint Hill Art Festival's Lifetime of Creativity Award, first time given to a poet

Clarissa Simmens

Even The Working Poor Go Hungry
(ENGINE BLOCK HOTDOGS, 1991 MEMOIR)

Hard to glamourize being poor
Especially when shopping at the Scratch & Dent store
My hourly wage was four twenty five
Just barely enough to keep us alive
Two teenagers eat a lot…

We couldn't afford the air conditioner
No help from the county commissioner
Didn't know about free food and power
Just lived from second to minute to hour
But I was out of icy Philly and in Florida…

My sons wanted to see the beach
An hour's drive, certainly in reach
But no money for charcoal and BBQ-ing
Wanted to impress them for family renewing
Why don't they like peanut butter and jelly, my favorite…?

Bought cheap hot dogs and wrapped in buns and foil
Couldn't afford ice and didn't want them to spoil
Opened up the hood of my dusty old car
Saw the engine block and had an idea so bizarre
To us living in trailers, engines are for cooking…

Parked by the Gulf, sat on the seaweedy beach
That day my sons learned what I was trying to teach
As we munched on the lunch
I delivered my punch:
Stay in school and never, ever be poor…

Clarissa Simmens is an Independent poet, Romani herbalist, ukulele player, and wannabe song writer. As part of the working poor, she has known hunger during various stages of her life, illustrated by her memoir poem. Hunger, in the 21st Century, is a crime against humanity…

KANSAS

Curtis Becker

My Childhood Teddy Bear

My childhood teddy bear
now sits in a rocking chair
unassuming, his look austere
I feel bad about his matted hair

"Is it love if it hurts you?"
I wonder aloud
He is stoic in his refusal to respond

Some of my friends ask "why"
Why do you keep that old bear?
That one with a missing clump of hair
The one resting upon the rocking chair

Loyalty?
Friendship?
Insecurity?
Innocence lost?

I used to care
that you might find out about my bear
that old austere lump of hair
slouching in that old rocking chair

That bear has a tattoo
of grape jelly
on his left ass cheek

That missing eye
makes him look B A
I should have found him the pirate patch

Mr. Bear?
Did Mike Tyson get ahold of your ear?
Stoic!

This survivor of my love
slumps over the rail
of my rocking chair

I do not see his pain.

My 5-year-old eyes see a bear
in good repair
with nary a tear
and all of his hair
There's no despair!

Thank you grandma, for giving me my teddy bear!

Curtis Becker is a poet, author, and teacher living in Emporia Kansas. Humor and wit are often his only weapons in the battle to make writing seem cool to younger audiences. His Snapchat game is on point, and his classroom persona is unconventional. He plays the trombone poorly and enjoys sharing trombone memes on social media.

Maril Crabtree

Landmark

The darker it is, the more like the devil he looks.
~ S. P. Dinsmoor, creator of The Garden of Eden, Lucas, Kansas

In 1907, with a sculptor's eye and a believer's vision,
he made a concrete playground for sinners who stray

from the straight-and-narrow I-70 highway. The devil
looks like Geraldo Rivera with horns. Eve towers over

him blank-faced and wide-hipped, while stone-frozen
snakes crawl everywhere. Here and there cement squirrels,

raccoons, pelicans – not your usual Eden dwellers – climb
among concrete trees. Griffons and angels perch side by side.

There's even a concrete American flag, something I'm pretty sure
wasn't in Genesis. You can see it all for six bucks. If you visit

his glass-encased tomb it'll cost you two more, but it's worth it
to see the remains of a man who put his own Eden on earth.

Maril Crabtree grew up in Memphis and New Orleans but calls the Midwest home. Her most recent book is *Fireflies in the Gathering Dark* (Kelsay Books, 2017), preceded by three chapbooks: *Dancing with Elvis* (2005), *Moving On* (2010) and *Tying the Light* (2015).

Anna Hefley

Out of my Hands

You used to fit
the span of my torso,
tucked like a Joey in the pouch
of his mother.
And I would place my hand
on the core of your body,

my palm covering every inch
of your soft pudding belly.
I watched every inhalation,

exhalation like a miracle
while smelling milky breath—
breathing in your air and then
giving it back to you
like you never left the give and take
exchange of my womb.

Your arms became strong
from the breath that I gave you
and your dimpled hands
strung beads on a shoelace
while your tongue
mastered the words that I offered

like gifts in silky paper.
And I heard every syllable,
held them up to the light
to watch like crystals and turn

over in my hands.
You took those words that
I gave you
and swallowed them down
like nourishment until
they made your bones grow
like reeds in the sand
and your legs became longer than
even my own.

I put your soft flesh into photos in frames
and the curls of your hair
like treasures in boxes.
I measured your feet against mine,
and while you felt big
with pride and showed me your
whisper of a mustache,
I saw the round cheeks that
had become a hard jaw
and wished for feathers of hair
and toes like baby grapes
and the sharing
of breath again.

Anna Hefley is a graduate student at Emporia State University. She is working on her Master's in English. She is a substitute teacher and mother of seven.

Nancy Julien Kopp

Kansas Burning--2017

On a golden winter day
in Kansas, cattle fed
on prairie grasses and hay
under an endless sky.

Peaceful clouds, gentle
breezes, brisk temps
until the powerful bent
of Satan shadowed all.

Where came the tiniest spark
that set the prairie ablaze
in only one small place,
with sudden gales and gusts?

Wind-whipped flames sped
across the prairie devouring
grass, hay, cattle and fences,
ranch homes threatened, too.

Billowing clouds of smoke,
charred ruins of prairie,
Cattle and calves dead,
others still bellowing in pain.

Ranchers, townspeople
and fire fighters toiled
night and day to no avail.
Fire won and men wept.

Six-hundred-thousand acres
burned, scores of cattle
 dead, or dying, fences
gone, homes smoldering.

A record-setting loss
of blazing earth
with Satan's handprint
branded over all.

Ranchers from nearby
brought hay and fencing,
searched for and buried livestock
dropped cash into trembling hands.

Spring- - a time of rebirth.
Herds will be replenished,
prairie grass will regrow,
broken hearts will mend

Nancy Julien Kopp lives and writes poetry, creative nonfiction, children's fiction and articles on the craft of writing in the Flint Hills of Kansas. She has been published in many anthologies, ezines, magazines and newspapers. Her blog is about her writing world with tips and encouragement for writers. Visit at
www.writergrannysworld.blogspot.com

Michelle Langenberg

*Alter Ipse Amicus**

...in the drawer was a pistol that he kept
for home defense. He stared at it,
trying to decide whether to go downstairs
and make a sandwich or kill himself.
~ Dean Koontz
From the Corner of His Eye

I have all wealth, for I am rich in friends,
dear people who have stopped their lives for me
when I, unraveling, was at loose ends,
and teetered at the edge of eternity.
Do you know what I'm talking about?
Only a dollar from an empty purse,
hanging from a cliff in the dark of doubt,
or even planning to reserve a hearse.

Then it is that a friend becomes your self
— your Other Self — to comfort and to hold
you to this world through love, and light up hell,
and help you to re-knit the raveled holes.
The heart of a loving friend! That is true wealth
worth more than any reckoning of gold.

* *Alter ipse amicus* (Latin): A friend is another self.

R.D. McManes

empty road

the highway is empty tonight
ribbons of concrete
dark asphalt patches
left and right are cities
and towns fast asleep
imagine the dreams
like millions and billions
of light bulbs
switches on and off
beyond the exits
beyond the mile markers
beyond empty corners
empty streets
empty crosswalks
empty hearts

the emptiness
a dark lonesome road
is almost too much
where everything
is forgettable
except the void
there is a deathly quiet
on the highway tonight

and in the neon distance
a pulsating sign breathes
in and out
"open 24 hours"

R.D. McManes is the author of seven poetry books. Mr. McManes has also had over 500 poems featured in over 110 world-wide publications. He has been a featured speaker, poet, and conducted poetry workshops for the Kansas Author's Club. Mr. McManes has been writing poetry for 50 years. He currently resides in Topeka, Kansas.

Kevin Rabas

Bathroom Break

The girl at the gym front desk says, "You don't need to check in again." I forgot my shorts, and so I'm circling until my wife gets off work and we go. I remember another time I showed up at a gym, needing to shit, begging to be let in, just for a minute, to squat, and the girl at the desk said no, and her big, muscly, built manager said no, and so I had to squat, pants off, inside a wooden dumpster corral outside my shrink's office. (Don't come so early. It's always locked.) I must've smelled like shit when he spoke to me, told me how to live within the lines.

Kansas Poet Laureate (2017-2019), **Kevin Rabas** teaches at Emporia State University, where he leads the poetry and playwriting tracks and chairs the Department of English, Modern Languages, and Journalism. He has nine books, including *Lisa's Flying Electric Piano*, a Kansas Notable Book and Nelson Poetry Book Award winner, *Late for Cymbal Line*, and *Songs for My Father: poems & stories*. His work has been nominated for the Pushcart Prize five times, and Rabas is the winner of the Langston Hughes Award for Poetry, the Victor Contoski Poetry Award, the Jerome Johanning Playwriting Award, and the Salina New Voice Award. A life-long Kansan, Rabas grew up in Shawnee and attended KU (PhD), Goddard (MFA), K-State (MA), and UMKC (BA).

Shirley Jamison Star

Kansas, Land of Oz,
Tornadoes, and sunflowers,
Beauty of Nature.

On our feet bottoms
There's no expiration date,
Not even "best by."

My electric trap
Caught ten rodents with pb-
No jelly needed.

Shirley Jamison Star lives in Ottawa, Kansas, where she teaches Suzuki Violin and Viola, Fiddling, and Suzuki Early Childhood Education. She constantly writes senryu (structurally like haiku) to keep her sanity.

PENNSYLVANIA

Carla Christopher

Pablocita

Kiss me. You
have taken my breath away.
Breathe for me.
Swell your chest in union
with the empty cavern
my belly has become. Create
the shape of Yin and Yang
then relentlessly tumble downhill,
seamless lack of edge and corner
creating unstoppable descent
from soft land to uncharted seas
below. I know no other language of love
than that of sea and sky
and I would have you take me into oceans.
Become a creature of gill and fin.
Relearn how to breathe
where there is no place your love
does not move against my skin.

Carla Christopher is diversity educator and artist-activist from York, Pennsylvania, where she was the fourth Poet Laureate, the first person of color and the first openly LGBT person to hold that role. Multiply published, she was awarded the key to the city not once, but twice, for her community and education based initiatives, and she believes unyieldingly in the power of the human story. More about her can be found at carlachristopher.com.

Le Hinton

Watching Antiques Roadshow with Tamir

He leans against the arm of a frayed brown
couch. I'm in the black vinyl chair. My West

Philly apartment has the logic of all dreams.
The scent of baking bread surrounds

us like a force field in a comic book or the sacred
breath of our ancestors. On the television a bow tie drones.

> *This cotton wreath is a piece*
> *of folk art from the late 19th*
> *or early 20th century.*
> *Notice the details in the bolls, the*
> *hard outside, the imaginary kindness*
> *of the fluff. There's an inflexible*
> *kernel inside, obscured by the white.*
> *There's a note attached. "It's hard*
> *to raise cotton. You have to feed and water*
> *it. Protect it from pests. It is hard to raise a child."*

Tamir stares at the screen and says nothing,
A dot of blood expands into the fibers of his wine-

colored tee, just below LeBron's *23*.

He places his hand over his stomach then glances

toward the kitchen, calls for his mom
or mine or anyone who can comfort a boy.

> *The patina on the handle of the whip*
> *tells us it was well-used*
> *and most likely dates from the early 1840s.*
> *There are brown stains at the tip*
> *which indicate great wear and use.*
> *If you can establish the provenance,*
> *who owned it, whose blood has browned the end,*
> *it could be worth a lot. It's been too many years*
> *for DNA testing to help.*

Tamir cups a bullet in his red palms. Offers
it to the screen. "What's your appraisal?" he says.

"I wanted to be a teacher or play pro ball.
I would have liked to have named my son."

He closes his eyes and sighs like an elder. "Do you
have an Xbox? I wish I could just play Madden again?"

Le Hinton is the author of five poetry collections including *The Language of Moisture and Light* (Iris G. Press, 2014). His work can be found in *The Best American Poetry 2014, Summerset Review, Pittsburgh Poetry Review*, and outside Clipper Magazine Stadium, Lancaster, Pennsylvania, incorporated into Derek Parker's sculpture *Common Thread.*

Jeff Rath

A Murder of Crows

It is always somebody else's war--
 a murder of crows
 circling
that burning village
across the valley--
until they descend
 on your hamlet
 like a shitstorm.

Their black eyes
reduce everything to blood and bone:
 their hearts are fists,
 I tell you.
They are night's patchwork quilt,
blanketing the landscape with woe:
 black air explodes,
 gunpowder breezes
 through splintered trees.
Destruction's whetstone rumbles
 like a neon moon,
 and sparks shower
 from the crows' bloody beaks.

And when they come
they come for you.
Swaggering up the village street--
 black uniforms
 instead of feathers--
 AK-47s across their shoulders.

They herd the children to a ditch,
the parents farther down the road.
It doesn't get
much more personal than this:

soldiers cuff and kick,
force us to kneel in the ditch.
They laugh
 and shout rude names
 as we cry.
Only Gramma defiantly squats
between the soldiers and us:
 her anger banked
 inside her now
 like a blacksmith's forge
because the soldiers want to hurt us.

Monsoons boil behind her gaze.
She shouts back at them
 in the language
 of the unarmed

and the unafraid.
Telling each soldier
in no uncertain terms
 that she'd like to do
 a little killing of her own:
that she's had enough
of soldiers and their wars.

She is killing them with her eyes.
 You can see this
 in the photograph--
 the look in Gramma's eyes--
though you cannot see
soldiers fall down
and rise up as crows--
 circling above the photographer.
Above his camera's eye.
A great black wheel of death
 circling the sky
 when this picture is taken.

And when the photographer
 steps away
 to snap something else
 that catches
his objective eye,
the crows begin their dive,
the soldiers open fire.

Jeff Rath is the author of four volumes of poetry: The Old Utopia Hotel (2016); Film Noir (2011); In the Shooting Gallery of the Heart (2009); and The Waiting Room at the End of the World (2007) -- all published by Iris G. Press.

TEXAS

Don Mathis

Feast and Famine in Six Words

I've got champagne appetite, beer budget.

Haven't had caviar for so long.

Don't eat sushi at bait stand.

All you can eat. He pays.

Ten cent beer, can't afford foam.

Holiday hamburger, eat like a king!

Homemade ice cream, poor man's riches.

Back yard bar-b-que, food stamp feast!

California produce truck, dollar a bag.

Stole a tip, bought a pie.

So hungry I ate dried peppers.

Expelled from the Garden of Eatin'.

Ate five pounds of Louisiana crawfish.

Squeeze the tail, suck the head.

Simple meal, loving hands, I'm rich.

What is "Doggie Bag" in Italian?

So hungry could eat a horse.

Everything tastes better when you're camping.

Spent all I had, still hungry.

Pockets are empty, belly is too.

Meat and potatoes guy; but broke.

Have my cake, eat it too.

A dessert, heading for a waistland.

Famished, until I finished second helping.

Don't criticize service until food arrives.

Food was great, such small portions.

Meal was lousy, and not enough.

Bum eats well, then he runs.

Eat to live, love to eat.

Once was starving, now I feast.

O 0 4 I 8 0 (Owe zero, for I ate nothing).

Wanted a steak, got a burger.

Chicken fried steak, dollar sixty eight.

One taco, but looks like two.

Big plate of food just evaporated.

Beggars' Banquet causes a Salivation Army.

Read the menu and I drooled.

So sad, Happy Meal is fattening.

Hungry eyes smaller than the plate.

Couldn't even afford a small appetizer.

So malnourished, couldn't eat at all.

Not in a hurry to fast.

Pay you tomorrow for hamburger today.

Hungry for everything, I've got indigestion.

Ate it all, pass the Tums.

Don's life revolves around the many poetry circles in San Antonio. Find him at Sun Poet's Society, the Open Mic Night at Viva TacoLand, or a variety of writers' workshops. Don's poems have been published in many anthologies and periodicals and broadcasted on local TV and national radio. In addition to poetry, he has also written policy and procedures for industry, case histories for psychological firms, and news and reviews for various media.
Thank you for your consideration.

J. M. McBirnie

The Primer of Hansel and Gretel

A mother doesn't let her husband find
her children starving at her feet; she'll bring
their bodies bent to the less fateful pines
whose woods will not withhold them anything.

The stubborn stones could lead their way back home,
but crumbs are feasts too moveable to hold;
So like all men, the boy learns to disown
the memories but seven hours old.

The siblings find a children's paradise
too sweet to last. The girl learns recipes
to lose a child; the boy, the awful price
a pound can make to women he can't please.

But soon they'll get a taste for aging flesh
and learn to feast on helpings of regret.

J. M. McBirnie is a poet and translator whose work has appeared in such publications as *Whistling Shade*, *Masque & Spectacle* and *The Jewish Literary Journal* and is the author of a forthcoming chapbook, *In the Dead of April*, by Local Gems Press.

Jeanie Sanders

Ballast

It was the same morning feel
that filled her stomach with the Sunrise.
She was hungry. The cotton sack was heavy
even without being filled yet. It dragged
at her already sweating back.

Heavy with her first child she was off balance
just walking. Bending caused the Earth
to meet her too quickly. But what choice
did she have? She worried she might
have her child between these very cotton rows
like Evie grunting in the dirt.

So she lifted her feet and moved. Bent and
picked with her already tired body. Like
a long necked crane moving on thin legs
she rose and fell. Sometimes cradling her
unborn child with a loving hand as she
dragged her burdens.

Jeanie Sanders is a poet and assemblage artist. She has lived in South Texas most of her life. She lives in Lytle, Texas with her artist husband and Italian Greyhound. She has been published in several anthologies, The Texas Observer and is a member of The Sun Poets of San Antonio, Texas.

Michael Verderber

left alone invalidated

Sleep deprived
Sets the precedence
Of apathy

Lethargy, hanging
By one thread.
Funny how alone
I am,
Always out of place
Amongst my peers:

Too young for the
Too old.
Too old to be with the
too young

Funny how the enemy
Offers the ship
He's as alone as I
Different circle,
Same boat
Different boat, same
CYrCLE.

Repeats; repeats
Again
Punctuating the
Cacophonous silence.

Am I the mistrusted?
Am I the one not to speak with?

I don't believe that
I'm just a
Different disease
In a doctoral world
My tonality differs
My focus.

Even today, I ate
Alone.

Irony: I'm tired
Of being surrounded
Yet tired
Of being alone.

How do I prove I belong?
Do I......?

Michael Verderber is a Texas playwright who specializes in writing plays and disjointed poetry. He has three books - "[nonspace]: theatre off the stage" (Fountainhead P), "Twas the FLOP Before Xmas" and "Still Standing Still" (both Sarah Book P) and has been published by Crab Fat Magazine, The Hourglass Magazine, In Between Hangovers, and others. His plays Libertad and The Problem with Robot Dogs were both staged Off Broadway in New York City and he was the Aug 2014 winner of Playwright's Express's "Best Comedy" for his play "GPS" (tie for first) in LA. He may be reached at ze-ro_untitled_films@yahoo.com

MASSACHUSETTS

Rick Blum

The Dance

Two bodies adrift in a glimmering galaxy of hope and angst,
senses overwhelmed by gravitational chords couched
in undulating beats, robbing them of reason,
drawing each toward the other, the space
between them becoming
infinitely smaller,
till,
limbs
entwining,
they pinball as one –
cheek to cheek, bosom to bosom,
groin to groin – around a now private
universe, until the final strum fades into silence
and centrifugal forces fling them back to the safety
of secluded solar systems…awaiting the next aural pulse
to once again arouse the inescapable pull of adolescent desire.

Rick Blum has been chronicling life's vagaries through essays and poetry for more than 25 years during stints as a nightclub owner, high-tech manager, market research mogul, and, most recently, old geezer. His writings have appeared in *Boston Literary Magazine*, *Form Quarterly*, and *The Satirist,* among others. He is also a frequent contributor to the *Humor Times*, and has been published in numerous poetry anthologies.

Tom Clark

Curse of the Rock

do you know the price of this water
do you know the price of this land
you who believe everything has a price
yet know the value of nothing
taken and crushed in the snow
so cold so cold

I speak as a friend who knows
that the Earth will stand against you
every rock and river
every fish and eagle and deer
every brother and sister
all of us together

the air you breathe is poisoned with greed
it tastes of metal and dust
a thin crust hardens on your lips
thickens the mucus in your throat
until breath black as smoke
billows from your lungs

you can pray to your money god
he will not listen
he has no ears

I tell you this
the wind will never stop
it will blow forever
the sand will cover all
even the oceans will fill with sand
is that what you wish?

then drill that pipe down to the core
suck every drop
then suck some more
you think you are winning
but the reckoning will come

so coke up the furnace
with that thick black goo
the bones you disturb
will become your own
this is all for you
every dark spot on the sun
every broken promise and treaty
every single one
I return them to you now
for everything you are doing
for everything you have done

Tommy Twilite (aka Tom Clark) is the Founding Co-director of the Florence Poets Society (2004). He is the long time leader of the eclectic rock ensemble, "The Tommy Twilite Orchestra". He is also the editor of "Silkworm" and the host of the "Twilite Poetry Pub" on WXOJ FM. Tommy recently retired as a Captain/EMT on the Northampton Fire Department after over 30 years of service. He lives in Florence, MA and devotes his time to poetry, art and music. His poetry has appeared in various publications. Tommy was the 2016 chairperson for 30 Poems in November, a literary fundraising event for the Center for New Americans.

Lori Desrosiers

Neighbor
(Baldwin, NY 1982)

My ex grew corn
in the tiny back yard
just a couple stalks,
also peas, tomatoes,
basil, rosemary,
pumpkins, squash.

The time we left
for a few days,
an old Chinese man
from down the street
had found our garden,
and we found him
on his knees
pulling weeds.

He stood, as if
he thought we
might be angry.
We thanked him,
told him to please
come back anytime,
he beamed.

Lori Desrosiers' poetry books are *The Philosopher's Daughter* (Salmon Poetry, 2013), a chapbook, *Inner Sky* (Glass Lyre Press 2015) and *Sometimes I Hear the Clock Speak* (Salmon Poetry, 2016). Her work has been nominated for a Pushcart Prize. She edits *Naugatuck River Review*, a journal of narrative poetry, and WORDPEACE, and online journal dedicated to peace and justice. She teaches Literature and Composition at Westfield State University and Holyoke Community College, and Poetry in the Interdisciplinary Studies program for the Lesley University M.F.A. graduate program.

Paul Richmond

It's Just A Loaf Of Bread

To be clear
They were both bread loves

They were lovers

Shared many loafs of bread
Had become connoisseurs of bread
Each had a favorite
There were a few they agreed on

Being a couple
There were discussions about the bread
How to keep it
Where to keep it
Remembering to close the bag
To keep it fresh
If it wasn't sliced
How to property slice the bread
Who gets to eat the ends

There were passionate moments
Bare hands
Squeezing and pulling
Until the bread released

Part of itself for feasting

Buying 5 loafs of the favorite bread
When it is available
And freezing it
Then the questioning of when
To bring out the next loaf
And why didn't you bring out bread
When you saw we were low
A few slices left
And Why
Did you bring out bread
When we have plenty and now it will go bad
Why do we always have to think about this

It was understood by everyone
That there had been some
Processing
Over bread
Some of the processing
Felt abusive

On walking into the kitchen
She noticed the bread was getting low
She took one out of the freezer
The night before
She then realized this was the day
That he was making bread
That having taken out this bread
There was going to be too much bread

He hadn't said anything about the new bread
From the freezer
She thought he hadn't noticed yet
She snuck
The bread back into the freezer
Thinking she had avoided
A possible
Need
For Processing

If you were going take bets
Did this clandestine action
Avoid any processing
We are sorry to say no

He asked why she put the bread
Back into the freezer

What
Was she doing?
What
Was she thinking?
It would taste horror-able frozen twice
Now that it had defrosted

They almost got into the finer points
Of defrosting
When was it really defrosted

They didn't go there

The bread was brought back out of the freezer

On the walk they took later
There was some bread
Between them

Paul Richmond - artist and performer for over 40 years. Created Human Error Publishing, organizes monthly readings and annual Word events / festivals, (Greenfield Annual Word Festival) publishes independent writers. Four books; "No Guarantees – Adjust and Continue.", "Ready or Not - Living in the Break Down Lane" and "Too Much of a Good Thing - In the land of Scarcity - Breeds Contempt" "You Might Need A Bigger Hammer". Fifth book due out 2017. Has been published in numerous journals, anthologies and has been a featured poet through out the country.
www.humanerrorpublishing.com

CALIFORNIA

Pat Andrus

Send a Hologram To My Stone

Send a hologram to my stone
if there I lie
inside a permanent memory.
Saved no more
but glad of faith
and winter storms that will
scrap my bones
into altars of marigold songs;
and roses for daughter's
pilgrimage into the sea,
petaled flight patterns,
crimson and burgundy heavens,
as she learns finally
her body's ease,
her soul's feed
of love and tender needs.

Pat Andrus, an MFA graduate of Goddard College, has workappearing in publications and anthologies such as "Hawaii Review", "California Quarterly", "Convergence" and *The Synesthesia Anthology: 2013-2017.* Her two published poetry works include *Daughter* (Olivewood Press) and *Old Woman of Irish Blood* (Open Hand Publishing). Andrus also has served two years as an artist-in-residence for Washington State.

Rose Bruno Bailey

Gravitational Pull

The moon followed me home, but I prefer the sun.

The moon hides behind secrets and shadows
only showing his face after dark.

A sinister celestial body of melancholy,
it tells white lies and retreats come dawn;
A giant crater of empty promises
and lackluster light.

The sun is warmth on my uplifted face.

The sun offers radiant life.

The sun is energy.

The sun is love.

The moon followed me home,
but I'll follow the sun.

Magnifique"

Mon Amour'
We have yet to meet.

My idea of you,
Your artistic history,
Your literary way
Soars my senses.

I would travel rough seas
To stand beneath you;
You, towering above
In timeless fashion.

I've imagined
Your French kisses
Would taste like butter
Melting in my mouth.

For you
I would lie
Nude
In a Monet
Meadow of lavender.

My dreams of you,
Delightfully decadent as
Wine in a lovers cafe
At dawn beneath
Your city's lights.

Breathless,
You bring out
My inner Mona Lisa.

Rose Bruno Bailey is a poet/writer/weight loss blogger and author of Camellia in Snow, her poetry collection; she is published online and in print. Born on the winter solstice in Cleveland, Ohio, she now resides in West Hollywood, CA. Her background is in theater with an emphasis on dance. She sponsors charities as she loses weight at www.mychangeforaten.com

Leticia Garcia Bradford

A Piece of the Whole

Every 28 days
I find myself
at the oncology center
for my multiple sclerosis
medical infusion
In the lobby
on a table off to the side
with every visit
There is a new puzzle
to distract us patients
from the reality of
why we are here
for the fleeting moments
we wait for our
life sustaining treatment

As I sit at the table
pondering pieces
Curious what contribution
I can add
to the 1000 parts
of this month's bucolic picture
which reminds me of the photos
my daughter instagrams

from Belgium
The borders assembled first
Builds the framework
Wondering what to join
I choose to sort like colors
A sense of calm
I haven't felt since
Grandma died on May 10th
the Mexican Mother's Day
comes over me

I wonder how many patients
have felt comforted
putting together the puzzle
Every visit feeling
part of a community
of healing
of positive patients
of dedicated nurses and doctors
of compassionate volunteers
committed to make our lives
worth living
despite our circumstances

On hollowed ground
This shared experience
hope
quiescent and harmonious
like an orchestra
Every instrument counts

as every puzzle portion
a piece of the whole
I am honored to be apart

Leticia Garcia Bradford performs around the SF Area Bay Area at open mics and readings. She founded B Street Writers Collective in Hayward, CA. She is published in various local and national journals, most recently in Rising Rains and the anthology FLY WITH ME which she is, also, the editor and publisher for MoonShine Star Co. Check out her blogs: MY NEW ADVENTURE at leticiagarciabradford.blogspot.com, and LETICIA'S BLOG at lgbradford.blogspot.com.

E.R. Buendia

The Hummingbird Dance

Your summer kissed skin glows in the sunlight
As the faint breeze sweeps the sweat off your brow
Hummingbirds fly touching upon tangerine flowers
As though the nectar is a gift from the heavens
The flutter of the hummingbird's wings
Sounds as sweet as an evening lullaby
On this perfect summer day, with harmony standing nearby
Waiting to send love darts to promising lovers
With your eyes closed, you imagine these darts beaming upon the birds
And fill your heart with hopes of an epic love story
Hope that was lost in the reckless abandon of heartbreak purgatory
Is this hummingbird a blessing?
Is it a sign of divine love? Is this your soulmate?
Or, are you drifting into the abyss of hopeless romanticism?
Tragedies of Keats, of every Romantic poet, who hoped the same
Is this a love doomed or an epic love that would last for lifetimes?
So you hope for a happy ending this time.
Pray for an ideal to come to fruition
And get drunk on the fragrance of infatuation

Infatuation or love? What's the difference?
The answer comes from a divine source
Yet you google it, hoping that you can find the answers

In Cosmopolitan Magazine or Marie Claire
Endlessly pursuing signs that he's the one
Perusing daily horoscopes and calling psychics
Hoping to get the answer you've been waiting for,
The One, One True Love,
In this dating apocalypse,
Does love still exist?

E.R. Buendia is from San Diego, California and currently works with the homeless at a non-profit as a mentor. She wrote her first poem at the age of eight years old, an appreciation of her mother's strength. E.R. enjoys practicing yoga, classic horror films, reading about the occult, and, writing short fiction. She is currently working towards her goal of becoming an English teacher for high school aged students.

Lori Levy

Just In Case

Some are probably dead,
but I water them anyway—the bare stalks
rotting in their baskets. The tangle of brown leaves.
I do it for the green shoots I can't see
but still believe might sprout, given water and light.

In the hospital, by her bedside, we tell ourselves she'll recover.
First her lungs stop functioning, then her kidneys.
We hold her hand, put wet cloths on her forehead.
Doctors give oxygen, dialysis, medicine, blood.
She surrenders to tubes. To nurses turning her, cleaning her.
We, her family, split time into shifts.

When it's my turn, I put my hand on her arm,
wish I knew what to say: something smart or funny or inspiring.
Instead, gloved, masked, robed, I ask her how she feels;
read my book—relieved—while she sleeps.

Two months, almost three, and still she lies there.

At home, I tire of pretending;
on an impulse, I gather up what's no longer green—
the ones water couldn't revive—
and take them out to the garbage.

217

My mother-in-law begins to wiggle her fingers.
Now she breathes on her own, two hours, four, eight,
and doesn't need dialysis. She is fed soft food.

To blur, to forget, I push pots this way and that,
play around with the survivors, but I miss my wilted plants.
The empty spaces scream blame. I gave water and light,
but did I tend, as in *tend*erly? Would it have mattered
—to them? to me?—if I had bothered to learn their names?

Lori Levy's poems have appeared in *Poeteer, Poetry East, RATTLE, Nimrod,* and numerous other literary journals and anthologies in the U.S., England, and Israel. One of her poems was read on a program for BBC Radio 4. She lives in Los Angeles, but "home" has also been Vermont and Israel.

Jim Moreno

Someone's American Son

I see him from my second story window
oblivious to the roar of the passing train.
He forages for supper,
slow-motion brown ghost,
with filthy hands
reaching into bowels of garbage cans
to devour egg shells,
then rancid fruit swiss-cheesed
by silent wriggling worms;
ragged suit clinging to dirt & bones;
greasy beard tracing gaunt cheeks—
haunted eyes of misty sorrow...
Commuters look the other way,
pass him bye on the way home
to feast on meat & potatoes.

Jim Moreno is the author of Dancing in Dissent: Poetry For Activism (Dolphin Calling Press, 2007) and two cd's of music and poetry. He is a Regional Editor of the San Diego Poetry Annual and on the Advisory Board of the Poetic Medicine Institute. Jim is the coordinator of the ReEvolutionary Poets Brigade and the co-host of 2nd Tuesday Jihmye Poetry Open Mic at the Cafe Cabaret.

Mary Langer Thompson

Wishbone in Moonglow

I leave you to the doctors
and nurses,
come home to our dark kitchen
still on the counter,
illuminated by a moonbeam.

We were going to split it to-
gether, but not now.
And anyway, it seems silly
to pull in opposite directions
as though rivals.

I step closer.
The bone's shape is an open heart,
and I know
that I want for you
what you need for me
what we hope for each other
until the clouds cover the moon forever--
that the light not leave us
tonight.

Mary Langer Thompson's poems, short stories, and essays appear in various journals and anthologies. She is a contributor to two poetry writing texts, *The Working Poet* (Autumn Press, 2009) and *Women and Poetry: Writing, Revising, Publishing and Teaching* (McFarland, 2012). She was the Senior Poet Laureate, 2012, for California. A retired public school principal, she lives in Apple Valley with her husband, Dave.

Jon Tobias

Scarecrow in a Field on Fire

I know I looked like a scarecrow
stuffed full
with tobacco and suicide notes.

Your fingers were matchsticks
on my back
tracing out the word,

"rest".

I am no longer heavy.

I am ember floating
all around you like fireflies.

A snow globe containing
the conflagration of sadness.

I know the word,

"love"

does not come easy for you.

It falls out in bites you meant to swallow.

I pick them off the ground and
press them into sheets of paper
like preserving plants.

I fill myself with that now.

Jon Tobias is an SDSU graduate and poet living in San Diego, California. He romanticizes everything. He doesn't mean to. It is just what he does.

Chris Vannoy

Day In The City

It is raining again
constant San Francisco rain
that escapes in great sobs
from gray sky

When the sun does come
it wakes the wide puddles
then reflects the undersides of umbrellas
as tires and wet feet
shake them to vibrated life

I just stand here and watch
the pigeons and sparrows
stop for a quick sip
they shake the rain from their feathers
then hop to sheltered ledges
tumbling against an agitated wind

Chris Vannoy has been writing for most of his life. Promoter, editor, teacher, and tireless advocate of words both written and spoken. He has been featured at the Beat Museum in San Francisco and has read from San Diego, California to Stockholm, Sweden. In 2017 he was appointed Beat Poet Laureate for the State of California by the National Beat Poetry Foundation, Inc.

LOUISIANA

Stephanie De Haven

How to Beg in the Modern World

Look at your children.
Swallow your pride.
Fill out the form.
Mail it.

Wait.

Watch the refrigerator empty.
The cabinets empty.
The children grow restless.
Tell them you're not hungry.
Listen to the wolf in your belly.

Receive a letter.

Use two gallons of gas
to retrieve required
proof of income,
proof of expenses.
Hand-deliver that.

Wait.

Coast into work on fumes
and try to look casual
while siphoning gas from
that bitch, what's-her-face.

Get an appointment.

Wait.

Go to a church you
don't believe in because
they have a food pantry
for parishioners. Only for
parishioners.

Cry.

Research the city food bank
between job two and job three.
It has a six month waiting list.
Tell the children that you're not hungry.
Learn to sustain yourself on hot water
and ketchup packets.

Wait.

See an article on Facebook from
your sister-in-law, the wealthy
hippie, that says that kids who
eat more than four hotdogs

in a month are doomed.
See that she tagged you and wrote,
"Makes you think, huh?"
Wish her nothing but yoga-inflicted
diarrhea and a sudden allergy to quinoa.

Receive an interview.

Take the kids, sullen and hungry
to an office full of sullen and hungry
children. Split half a pack of saltines
with them and call it a picnic.

Wait.

Meet a rude woman who doesn't like you
and answer a pile of invasive questions.
"Where is their father?" Over and over.
Like seeing the family for holidays.
"We'll be in touch."

Wait.

Worry that you didn't appear poor enough.
Worry that she saw how skinny your son is these days.
Worry about CPS. Worry.

Receive your decision.

Cry.
Either way.

Stephanie De Haven lives in Lafayette, Louisiana with her girlfriend and their ten cats. She writes about life, death, love, disability, and dragons. Her work has most recently appeared in Tanka Journal, Vitality, Hoax Journal, and Inwood, Indiana.

John Lambremont Sr.

The Point At Montauk

The striped lighthouse is an exclamation,
a stanchion bastion against the surging sea beyond,
but the fathers that founded it knew all too well
that the pounding ocean is a prodigious foe,
a relentless and unceasing batterer
of batture and all that lies below,
so they built the lighthouse high and away,
some three fields back from the rocky sands
that formed the craggy, scraggly beach.

Time has proven the founders' prescience,
as the waves' unending wear and tear
over decades and scores of two centuries plus
has worn the flinty soil away,
yard by yard and acre by acre,
imperiling the lighthouse, now a landmark,
and endangering its mission of mariners' mercy.
The solution reached was Herculean in scope,
the selection, sculpture, and careful placement
of giant slabs of black basalt and mica-flecked granite,
rising in tiers from the sea bed thirty feet upward,
forming a rip-rap of the greatest order possible,
huge building blocks laid with pyramidic precision
so as to create a make-shift walkway,

a parapet for appraisal of what next the sea might bring.

Today, Neptune's children seem playful,
gently tossing wavelets across the breach,
while two wet-suited surfers out of season
send out hoots of illicit delight
as they catch and ride briefly
the eighths of waves.

John Lambremont, Sr. is a poet and writer from Baton Rouge, Louisiana. His poems have been published internationally in many reviews and anthologies, including Pacific Review, The Minetta Review, Clarion, Raleigh Review, and Sugar House Review, and he has been nominated for The Pushcart Prize. John's third full-length poetry collection, "The Moment of Capture," will be published in the fall of 2017 by Lit Fest Press. John's other poetry volumes include "Dispelling The Indigo Dream" (Local Gems Poetry Press, 2013), and a chapbook, "What It Means To Be A Man (And Other Poems Of Life And Death)," (Finishing Line Press, 2015)

NORTH CAROLINA

John Amen

Grace

for Stefan

In the beginning, a little blind spot,
o little big bang, little blind spot
becomes the universe, gives gravity a job,
keeps you clutching your hand grenade,
fingers twitching on the lever—
ok to think but not to throw ok to think but not to throw
Remind yourself: it's 2017, don't let 1971
detonate in your lap, take out the living room,
the house, the dream it's taken decades to find,
years lost in the swamp & fire.

I'm not the first to experience
effort as little more than a bunker
to hide in while inconsequence,
with its platoon of dead-ends & sabotages,
marches its way, a monsoon
rearranges the furniture, indifference
cranks up the volume on the radio.

I don't like writing my own obituary
while across town another part of me is christened;
still, I wear *brother you better believe*

none of this is going to work out
like a suit of armor, like a drip IV.
Like bulletproof wings I flap to find
someone else already signed the contracts, delivered the mail,
threw his body between the exploding grenade

& the rest of the world. My years
have been punctuated by small salvations
I can never explain, they arrive like sleep or waking,
like going home the morning after the bunker's lost,
always the morning after.

John Amen is the author of several collections of poetry, including
strange theater (New York Quarterly Books, 2015), a finalist for the
2016 Brockman-Campbell Award and work from which was chosen
as a finalist for the 2016 Dana Award. He is co-author, with Daniel Y.
Harris, of *The New Arcana*. His latest collection, *Illusion of an
Overwhelm*, was released by New York Quarterly Books in April
2017. His poetry, fiction, reviews, and essays have appeared in
journals nationally and internationally, and his poetry has been
translated into Spanish, French, Hungarian, Korean, and Hebrew. He
founded and continues to edit *The Pedestal Magazine*.

SOUTH CAROLINA

Danny P. Barbare

Figs for Pecans

My neighbor brings figs each
year that are busting
messy softness
with seedy red ripeness.
Sweet as sugar like candy.
We put them in the frig
in the plastic bag
eat them like dessert.
It reminds me of my grandparents'
backyard next to the silver
painted oil tank, near the
loose wire fence, where
I know a fig bush is.
I remember how delicious
they are and giving my
grandparents as I fill
a paper bag full of figs.
But mostly gobble them.
I often wonder if it's still there.

Danny P. Barbare resides in the Upstate of the Carolinas. He attended Greenville Technical College. He lives with his wife and family and small dog named Miley.

Frederick William Bassett

Taking Sides

With no intent to kill the snake,
he chose to remove the intruder
from the tinny bluebird house.

Shaken by the outcome,
he left the deed overnight
at the edge of the yard.

The fire ants, in turn, left him
a wad of blue feathers awash
in a wave of delicate snake bones.

Frederick William Bassett is a retired academic who lives near his grandchildren in Greenwood, SC. His poems have appeared widely in anthologies and journals, including *Georgia Review*, *Illuminations*, *Mudfish*, *Negative Capability*, *Passager*, *Pembroke Magazine*, *Poem*, *Slant*, *The Cape Rock*, *Timberline Review*, *Yemassee*, and *Zone 3*. He has four books of poems, the latest being *The Old Stoic Faces the Mirror*.

ILLINOIS

Mark Hudson

Dill Pickles and Cheetos (Two Sonnets)

Muncie

In Muncie, the birthplace of the Garfield cartoon,
Ball State University attracts thousands to learn.
Lowery's Candies makes chocolate with spoons,
that make magical creations that make folks yearn.
Chocolate dipped Cheetos make people croon,
and have not caused dieticians concern.
The Ball brothers moved there during the gas boom,
bringing their glass factory in order to earn.
The founders made a town where people consume,
and Chocolate Cheetos make people return.
It's not the product that one would assume,
could stop you from a case of heartburn.
If you ever get there on a vacation,
they also have a museum of aviation.

Greenville

In Greenville, Mississippi, students in third grade,
have taken dill pickles to another dimension.
They like to eat pickles encased in Kool-Aid,
and no one is sure who made this invention.
Cheetos dipped in Ice Cream they too have made,
I guess kids like candy with deficit attention.
The pickle brand is known as Best Maid,
and the grocery stores are paying attention.
Children's candy makes adults get paid,
the origin of the candy man's intention.
Are these odd combos phases that fade?
Will these get so hyper they'll get a detention?
I don't know, but it makes me crave candy,
the thing that my kitchen doesn't have handy.

Richard King Perkins II

Foretoken Beach

Sometimes, I can almost hear you.
Did you know that?

Not actually your voice,
but the little dreams interspersed
between your words,

the tiny catches of desire
inaudibly leaving your vulnerable throat.

The fields of sand are too sloppy
for the children,

saturated with art unending

and starlight,
the mainmast of broken midnights.

Every effort has been made
to trace the proper owner of
this copyrighted material

but I've simply decided whatever this is

belongs to me.

There is no reason playing hard-to-get

when we've already had each other
in every way available,

auguries of inescapable betrayals.

Someday,

you'll wonder why you ever hesitated.

Richard King Perkins II is a state-sponsored advocate for residents in long-term care facilities. He lives in Crystal Lake, IL, USA with his wife, Vickie and daughter, Sage. He is a three-time Pushcart, Best of the Net and Best of the Web nominee whose work has appeared in more than a thousand publications.

OREGON

Keli Osborn

Winter Morning at the Public Library

Two 'til 10, and the air is moist
with yesterday's sweat. Tobacco cologne
loiters, insistent as a hangover.

Tugging loose threads and tight coats,
patrons hoist bags, exhale malt
and coffee. Coins clatter to the floor.
A time traveler might take them
for medieval serfs, expectant mob
at the palace gates straining for a peek.

A thin man with a goatee and suit coat
approaches the glass lobby,
and with a snap unlocks each door,
ushers in the flock of murmur,
the cotters and bookworms,
throng pushing ahead:

Straight line to the well-lit corner,
cozy chair, tiled lavatory—
away from the borrowed sofa,
limb-lined riverbank, beyond
dank alcove or underpass—

this snug and tidy fortress, secure.

They rock and rest among volumes,
the gleaming words and pictures,
these provisional royalty in the stacks.

Keli Osborn writes and lives in Eugene, Oregon, where she co-coordinates the Windfall Reading Series, and works with community organizations. Her poems appear in Timberline Review, San Pedro River Review, The Fourth River and Elohi Gadugi, and the anthologies, The Absence of Something Specified and All We Can Hold.

NEW MEXICO

Bobbi Lurie

Homeless Outside The Church

Tall shadows, bent in places, cover and uncover me.
Gesticulating strangers crowd the entryway
Where I am planted like a crop growing human feelings.

The marquee on the church says: *Blessed Are The Meek*
But the religious who weep, who enter
Turn their heads to profiles as they pass.

I am tarnished by the sun, weathered over
On this particular Tuesday. April and
The rank smell of humanity fills me.

Sounds from the choir leak through to the street
But their songs do not touch me,
Not even in the barefoot places.

Only the occasional kindness of a stranger,
The curve of his back, a slope rushing past me,
Is luminous, the coin pressed in my hand . . .

And yes, I beg.

I open my palm

As Jesus did.

 X

The Sisters of the church arm in arm,
Covered with the black protection
 smile as they leave,
Welded in belief and the repeatable.

11

I am shamed by my separated spirit.

 X

I press myself deeper
Into the mute tulips,
This bedspread where I lay my head at dusk.

Clouds threaten to stroke me with pneumonia
But I welcome the thought of the hospital cot.
The boldness of death, yes, I welcome it.

The skyline stretches itself out like a lie.
The city darkens into twinkling lights.
I rest my face in the gentle, gentle
 rain.

Bobbi Lurie is the author of four poetry collections, most recently "the morphine poems." She is currently working on a book about /with Marcel Duchamp. She lives in New Mexico.

WASHINGTON

Cheryl Latif

uncharted

he walks under the bridge destination uncharted

a strapped and zippered keeper of possessions
hunch his shoulders, yet it's his gait
that speaks the weight he carries

come night he knows cold concrete
traffic lullaby carries the air
stars hide in city's glare

the cacophony of countless nights
brings freedom
borderless dreams
until dawn's rooster pours in his ears

another day another day another day…

would that he stay in those dreams

Cheryl Latif's work has appeared in local, regional and national publications and anthologies, including *New Millennium Writings*, *The Comstock Review* and *Spillway*. The former curator and host of San Diego's nationally known weekly reading, Poetic Brew at the Claire de Lune, she served as a judge for the San Diego Writers Cooperative, (2002); Berkeley's Bay Area Poets Coalition (2003); and San Diego's African American Writers and Artists (2003) poetry contests. Now a resident of Seattle, her manuscript, *body language* (now under a new title) reached semi-finalist status in *The Word Works* annual contest and continues to be a work in progress.

OHIO

Emily Reid Green

On Allowing Flowers

A child will ask you if there are flowers
in space. It will happen one day and you
must choose between scented blossoms and
only dust. Do not wish for ambiguity for there is
only one story when gardens and galaxies are the
only offerings. Give no hesitation- The void uncoupling
possibility and certainty is a single breath, the child is
wobble wonder enough without added danger of
prolonged pause. Perhaps a deadline is needed:
Meet it with bouquet in hand and child too. Toss
petals like stars without counting, without worrying over
destination. It is enough to know they fragrant
the atmosphere, that fixed filament they cluster
bloom among constellations the child discovers
by telescope, by naming. Not of fear but of
fascination. Not like us, letters locked in place,
pressed imprint. We were never painters or maybe
we were painters once. A nova, we lit the canvas
technicolor, now sleeping gray for so many years.

Let the child dream awake the dark
matter, of perfume patterned orchid, of
waxing moonflower.

Emily Reid Green's poetry has appeared in Khroma Magazine, Gravel, The Font, and Common Threads. This spring, she was a sponsored poet with Tiferet Journal. An avid knitter and unabashed bookworm, she lives in Toledo, Ohio with her family.

NEW JERSEY

Ayesha Karim

The Psalmist a poem

When my mother travels through my mind I think of all the unconditional love she gave to me.

How my mom cared about me in a way few others did.

I think of the Biblical psalmist who said "when my mother and my father forsake me the Lord will take me in" and put my fears to bed.

Jesus will tuck me in and I will sleep like I do now in my 30s like my sleep is restoring my soul.

God's mercies are new every single morning.

Most nights I get good sleep.

Some nights I wake up at 3am or 4am but now I know "Ayesha you need to go back to sleep until at least 7am or 8am".

Sleep is essential to my success being as busy as I am.

I love being busy.

It's a part of my (Ayesha's) life.

Ayesha started poems when she was in the 5th grade. Ayesha is an Early Childhood Education co-major. Ayesha has a BA in English from NJ City University in Jersey City, NJ. Ayesha is 36 years old. Ayesha loves cats, writing and any shade of the color pink.

ARIZONA

Bonnie Papenfuss

Hunger

I picture them on the shelf
waiting there for me to yield;
but I've much to do
no time to indulge.
Certainly, no time to indulge!

I busy myself with household chores,
ignoring their beckoning.
No time for them right now;
other things come first.
Yes, other things come first.

But they haunt my consciousness,
such temptations they've become;
summoning me while I scrub and dust
wanting to be foremost.
Always, wanting to be foremost.

Inevitably, I succumb
to the persistent, gnawing hunger,
take up my writing tools,
and feed my soul with words.
Indeed, feed my soul with words.

Bonnie Papenfuss has been a resident of Green Valley, AZ for thirteen years. She enjoys writing poetry about nature and the perils of growing older. She also writes book reviews for the local newspaper. Bonnie has had poems and short stories published in nine separate anthologies, including OASIS Journal 2013, 2014, 2015, & 2016.

WEST VIRGINIA

Mark Danowsky

Snapshots

1. Expectations

It's Saturday, 8:30am
a bright Spring morning
though the calendar would disagree

I step outside just as the 65 bus pulls away & a man walks by
wearing a jean jacket with a patch that reminds me of *Space Jam*
& white sneakers cleaner than my own

He offers a toothy smile
then asks if I'm about to throw away
bags full of laundry in my hands

2. Slump

When I step onto the stoop
& return a work shift later, the same man
sporting a Taqiyah & thick gold chains
stands at the bus stop shouldering his duffel bag
once again says, *What's good*
—but not in question

On the morning walk
overheard a kid whisper to his classmate
That's the dog who got shot

Across the street
the flowering cherries broke
an otherwise gray sky

Just one of those days
when it feels like you cut your nails too often
talk is yelling & waking empty-
headed, you scan the radio for community
& find only nostalgia

3. Growth

On their way to school, the neighborhood kids
know to wait for the light before crossing

First I think they just want to say hello to our border collie
until I see the fraying stems of daffodils
clutched in their puffy hands

Without reservations, one boy pulls up another curbside bunch of
daffys
beheads a lone blue hyacinth & snaps low branches
from the flowering cherries

When asked who the flowers are for

he hands me a yellow daffy with a bright orange center
but I return it even before one of the girls lets me know
they are meant for Ms. Carter & Ms. Bryant

Mark Danowsky's poetry has appeared in About Place, Cordite, Grey Sparrow, Shot Glass Journal, Third Wednesday and elsewhere. Originally from the Philadelphia area, Mark currently resides in North-Central West Virginia. He is Managing Editor for the Schuylk-ill Valley Journal and founder of VRS CRFT, a poetry coaching and editing service.

Daniel McTaggart

Drink The City

If I sit all day in this café I am a river
Lapping at coke and beer bottle banks
People come inside for a cuppa
Skipping like coin-sized pebbles
Smoking till taxis swing by the curb

If I walk main street at night I am
A flood tricking along gutters filled
With discarded gum lost pennies
Scraps of half-written notes
Glum thumb-worn tickets

If I drive around corners I am a cloud
Diffusing traffic lights and cursive
Neon blinking in sultry windows
Wet tires crackling over sparks
Expiring in a wisp of motion

If I live in the city I am a straw
I am a limber loose tree
Waiting for any storm to shake
And embrace
My perspective

Daniel McTaggart is the Beat Poet Laureate of West Virginia, editor of Diner Stories: Off the Menu, and a frequent contributor to Kestrel and Amomancies. He thinks jazz and the smell of coffee are pretty much the same thing.

DELAWARE

Ann Christine Tabaka

Freedom Journey

Among the ruins of broken lives,
they came across great expanses,
searching for a place to rest their weariness.
Empty from hunger.
Full from hope.

Carrying with them stories of their pasts,
and the bones of their ancestors.
Multitudes marching,
while looking out over myriad expressions,
in quest of a familiar face.

Grasping the future in clasped hands
tucked into worn pockets.
Afraid to let go,
lest dreams scatter like lost seeds
among devouring crows of indifference.

Tiredness overtaking,
broken bodies pitch tents
of sparse comfort.
Taking refuge along the never ending
journey of freedom.

Ann Christine Tabaka lives in Delaware. She is a published poet and artist. She loves gardening and cooking. Chris lives with her husband and two cats. Her most recent credits are The Paragon Journal, The Literary Hatchet, Metaworker, Raven Cage Ezine, RavensPerch, Anapest Journal, Mused, Indiana Voice Journal, Halcyon Days Magazine, and The Society of Classical Poets.

INTERNATIONAL POETS

PUERTO RICO

Sergio Ortiz

There were windy streets

and cold suns on my skin,
his wounds still shiver inside me,
and days that came from death
to cast his face in every hour,
a soldier lost in the ice of his Gulag,

who forgot the why and where
of survival. Eyes seek the slipstream
of trains rumbling to the void.
Birds bequeathed their footprints
on his snowy back.

My eyes have not seen him,
the memory of streets that come
from night and run parallel to death.
I, the exhausted soldier,
the residue of undefeated battles.

for the children murdered with chemical weapons in Syria

Sergio A. Ortiz is a two-time Pushcart nominee, a four-time Best of the Web nominee, and 2016 Best of the Net nominee. 2nd place in the 2016 Ramón Ataz annual poetry competition, sponsored by Alaire Publishing House. He is currently working on his first full-length collection of poems, *Elephant Graveyard*.

UNITED KINGDOM

Benjamin William Crisafulli

Pretty homeless

Her caramel complexion hid her narrative,
And I didn't ask.
No bucked teeth,
No smack-banged jitters
mixed with incoherent stutters...
but beauty in the most surprising of places.
Piccadilly Gardens on a sunny Mancunian afternoon
the busy city stands in shock
at the thought that anything can happen.
Without the badge such beauty would be deceptive...
She doesn't look homeless.
But she's pretty homeless.
This ardent atheist accepts her thanks, her God bless
and goes on his way...
a bard, a vagabond by choice,
a regal rogue with a heart of gold
but no time to hear the real Big Issue...
her story,
transient in a fleeting, ever moving
world.
Pretty,
Pretty homeless.

SWEDEN

Bengt O Björklund

garbled into oblivion
where why never finds an ear
no one has read the book

solemnity is a remnant
from times on no potatoes
praying for drops of hot gravy

holster your herbal shot cowboy
move across the known garden you
like a fiend on a green holiday

it is only I bleeding navy blue
across these clear caerulean skies
where secrets are so obvious

Bengt O Björklund, called Erich in the movie Midnight Express, has written poetry since his days in jail in Istanbul 1969 - 1973. He has published six book of poetry, five in Swedish and one in English - written in English - published by Iconau publishers in Wales. Bengt is a poet, a cook, a journalist, a percussionist, a painter with many exhibitions through the year.

POLAND

Eliza Segiet

It Was the Same

Translated by Artur Komoter

There will no longer be home,
smoke from the chimney.
There will be no tomorrow.
Rotten beams
cannot withstand the pressure of time.
In the crooked house
a hunched woman
– waits.

It's like it used to be,
out there behind the house flows a river.
Only now
the children do not have time to look at old age.

Time took away youth
– like the night takes away the evening.

There is no longer smoke from the chimney,
no chimney,
and there behind the house
still flows a river.

Eliza Segiet – graduate with a Master's Degree in Philosophy, torn between poetry and drama. Likes to look into the clouds, but keeps both feet on the ground. Her heart is close to the thought of Schopenhauer: *Ordinary people merely think how they shall 'spend' their time; a man of talent tries to 'use' it.*

MEXICO

Alicia Minjarez Ramírez

The Path Of Your Steps

Translated by: Alaric Gutiérrez

Naked and lurking
Tenderness
At the riverbank,
A kiss clinging on
As a vine
And climbing
Through the sap
Of my branches.

I spy on the night
In your thistles,
Adjacent meridians
In the nectar
Of your Nile.

Of all your summers
Emanate and disappear
Crepuscular fragments,
Frosts decorate
The melodic chant
Of orioles
And blackbirds.

I invent you and lose you
In the zephyr choleric notes,
The sublime lightness
Makes silence thunder up.

Dissolving my dawns
In the hustle of memory,
Fire against the light
Of the stranger and nubile
Torso of your body.

You rain and crumble
Over my fragrant touch,
Blast that exalts
The sound of the stones
Building up my roads,
Long gone
And desolated landscapes
Blooming today
Behind your own steps.

GREECE

Chryssa Velissariou

Humans or Just Mammals?

What do we reassure for real in a world of pain except our personal fantasies? Do you see them, mother? Do you see the homeless, the hungry ones, the slaughtered ones, the wronged ones, the sick ones, the criminals? Do you really see them? Do you realise that your sons and daughters can sooner or later become a part of the Whole World's Miserable Ones? Have you ever consciously had even the slightest suspicion about this probability? Have you already had this frightening nightmare? Has it passed from your mind that Your Roses could wither, That they will probably grow thorns? Well I, I never felt secure in my fake success... If you find a way to cease this worldwide dearth you find a way in fact for your family Believe me! I saw it with my own eyes The Beast is near

Take a Look At These
Other Local Gems Publications

The Poets' Almanac 2017
A Poetry Lover's Journal

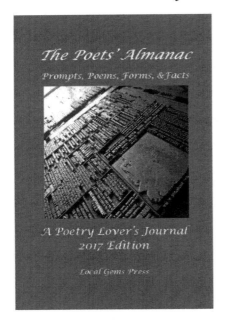

The Poets' Almanac was designed with the poet in mind. The Poets Almanac: A 30 Day Poetry Prompt Journal (With enough prompts to last at least 60 days) as well as ample writing space.

Information on poetry forms. Historical poetry facts Some wonderful short poetry. And a great article on making a good poetry workshop!

Published by Local Gems Press
Available on Amazon.com!

Japanese Poetry Forms
A Poet's Guide

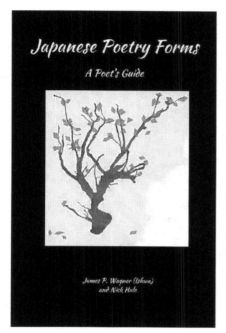

When people think of Japanese poetry, the Haiku is the first thing that comes to mind. But the Haiku did not become the Haiku we know until a thousand years after the first manuscripts of classical Japanese poetry were written..

Learn about the Renga, the Tanka, the Sedoka, the Choka, the Haikai, the Dodoitsu and others. Learn about the Japanese death poem tradition and read some poems by Zen Monks that are up to 700 years old.

Learn the history behind the vibrant culture that gave rise to so many wonderful forms of poetry, and how to write them.

Published by Local Gems Press
Available on Amazon!

Laurels
Poems by Long Island's Poets Laureate

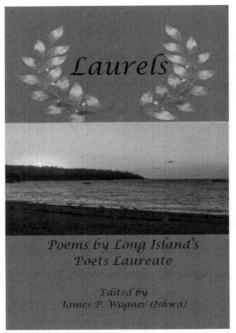

Long Island has been blessed with various accomplished and invigorating poets laureate who help spread the art and encourage it. For the first time, their work has been put together in an anthology made easy for the average poet/ reader to appreciate.

Laurels features poetry by the various poets laureate of Suffolk and Nassau county, as well as a few thoughts from the laureates themselves.

Published by Local Gems
Available on Amazon.com!

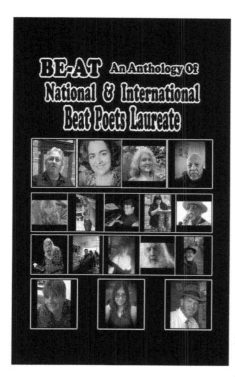

The National Beat Poetry Foundation and Local Gems Press have teamed up and are proud to present this one of a kind anthology of poetry by National, State and International Beat Poets Laureate.
, Featuring poetry by...

National Beat Poet Poet Laureate & 1st International Beat Poet Laureate:

William F. DeVault, 2017-2018.
George Wallace, 2015-2016
Lori Desrosiers, 2016-2017.
Dr. Chryssa Velissariou International Beat Laureate
- 2017-2018 from Greece

1st 10 NBPF State Beat Poet Laureates - 2017-2019:

Chris Vannoy - California, San Diego,
Annie Sauter - State of Colorado,
Ernel O. Grant - State of Connecticut
Paul Richmond - State of Massachusetts
Carlo Parcelli - State of Maryland
Marci Payne - State of New Jersey
James P. Wagner - New York, Long Island
Viviana Grell - New York, New York City
Ngoma Hill - New York State
Daniel McTaggart - State of West Virginia.

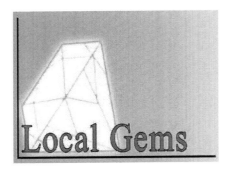

Local Gems Poetry Press is a small Long Island based poetry press dedicated to spreading poetry through performance and the written word. Local Gems believes that poetry is the voice of the people, and as the sister organization of the Bards Initiative, believes that poetry can be used to make a difference.

www.localgemspoetrypress.com

Made in the USA
Middletown, DE
25 June 2019